Images of Modern America

TENAFLY

Images of Modern America

TENAFLY

PAUL J. STEFANOWICZ

ARCADIA
PUBLISHING

Published by Arcadia Publishing
Charleston, South Carolina

Printed in the United States of America

Library of Congress Control Number: 2016936937

For all general information, please contact Arcadia Publishing:
Telephone 843-853-2070
Fax 843-853-0044
E-mail sales@arcadiapublishing.com
For customer service and orders:
Toll-Free 1-888-313-2665

Visit us on the Internet at www.arcadiapublishing.com

*Dedicated to our complete Tenafly family—those still with us
and those who have passed on but live on in our memories,
and those near and far. Home is always here for you.*

CONTENTS

Acknowledgments

This book was written with the generous help of many people. I am grateful to have heard the stories, met the people, and included the history in this volume to further Tenafly's legacy.

I would like to thank Henry Clougherty, my title editor, who has been extremely patient and kind as this project hit some bumps in the road. Alice Rigney, our borough historian, brought me into the historical fold and speaks my language. What a jewel in the lives of my family she is. Sam Bruno is a go-to resource on anything or anybody Tenafly and local sports, and knows more lore than he cares to admit. Dave Wall filled a notebook with interviews of prominent residents years ago, storing it away, thinking it might never get used. Thank you for saving it! Rob Nelson kept my spirits and the Tiger spirit alive at all times. Louis Dotti (THS '85) kept telling me that I can do better—I have to listen to you more often! Anthony Sammarco fielded my questions patiently and continues to shine a great deal of light. My mom and dad and brother Jeff and his family helped me make my own memories of these wonderful years. To Mayor Peter Rustin and the council, and the entire staff at Borough Hall, our police and fire departments, and the board of education, as well as town volunteers and organizations of all kinds, I am honored to sit alongside you. Lastly, I would like to thank my wife, Joanne, and son Nick—a historic preservation commissioner of the 21st century—for their unfailing support and understanding always.

I am appreciative of the following people for their generous donations of pictures or information, often on short notice: Robert Benson; Bob Beutel; Sam Bruno; the Tenafly Public Library; the late Athena Chagaris; Rita Clark; Michael DeAngelis; Christine Evron; Ginny Giardini; the late Helen and Bud Giordano; Rita Heller; Betsy Powers Hodges; Bob Hofstetter; Jay Huguley; Bill Jaeger; Kim Kuenlen; Dan Lane; Deborah J. Littler; Matthew Maher; John McNamara; Rosemarie and Don Merino; Anne Moskovitz; the late Virginia Mosley, former borough historian; Robert Nelson; Karen Neus; George Pituras; Charles Price; the late, great Ray Rancan; Alice Renner Rigney; Margaret Robbiano; Peter Romano; David Sokol; Joe Sposa; Nicholas Stefanowicz; Tom Swift; Richard Trebino; Kevin Tremble; Susan Hemberger Van Poznak; Dave Wall; Bob Ward; Jon Warms; Jeffrey Wong; Debbie Bodecker Zaccario; and the late Joyce and Don Zeiller.

All photographs, unless otherwise noted, are courtesy of the Tenafly Historic Archives.

INTRODUCTION

This volume focuses on Tenafly in the second half of the 20th century and beyond. The early years as covered in Images of America: *Tenafly*, the first volume, showed a quiet railroad community grow into a village. That village came to life as businessmen moved to town alongside the farmers who had managed the land.

As we moved into the 1950s, Tenafly experienced a postwar boom. Parts of town that had only been open space or large estates were purchased, subdivided, and developed. The number of schools eventually grew from one public junior-senior high school and two elementary schools to separate middle and high schools and four elementary schools. Churches and temples were renovated, and new construction and shopping centers popped up downtown. Population hit a peak in 1960.

Although in many ways Tenafly evolved, the spirit of the town remains the same. The downtown has changed, but kids and families still meet up there and enjoy it. Tenafly has more quality recreation facilities today than ever. Our parades, holiday celebrations, and traditions of yesteryear all carry on, with some new ones added along the way. Our parks are well kept and always busy with various activities.

If you have lived in Tenafly, the town becomes part of who you are. You may move away, but your memories and friendships remain. Hopefully this book will bring some fond ones back into the forefront of your mind, making them fresh again. A town is made up of land and houses, but people make those houses into homes and a town alive. Tenafly's history belongs to all of us to share!

One

SCHOOLS AND SPORTS

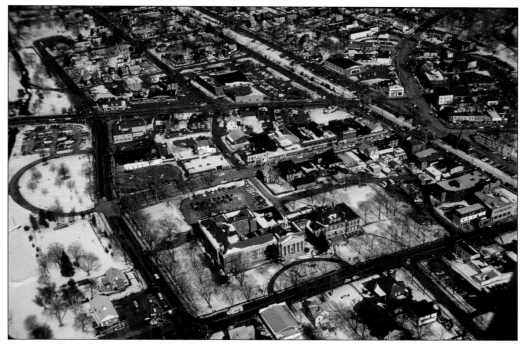

This is a late 1960s aerial view of Tenafly from above the original high school and Browning School. By the time this photograph was taken, the new high school on Sunset Lane had opened, and this was the junior high school. The downtown and vicinity is visible in the background.

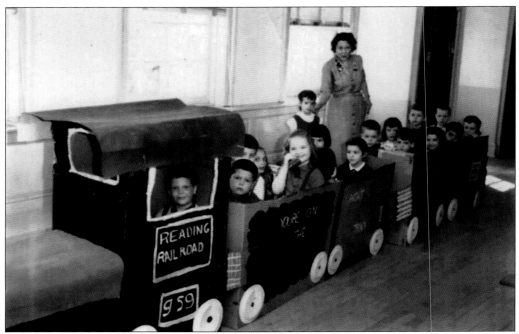

A prominent and endearing feature of the Maugham School was its kindergarten suite, located in the front of the school building, facing Magnolia Avenue and the flag pole. Here, the beloved Mrs. Ruth Dobson shows some students how to head off on the railroad in 1963. (Courtesy of Kim Kuenlen.)

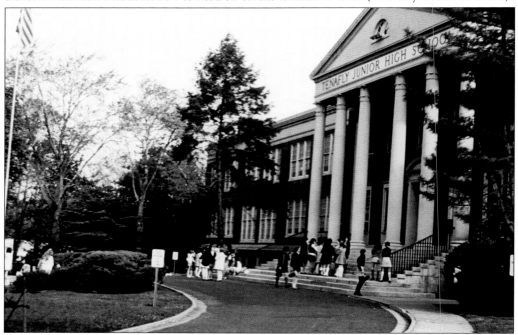

This late 1960s view is classic because many who went to school during that era remember this building as both Tenafly High School until 1958 or Tenafly Junior High School until 1971. It later held administrative offices and is now part of the Browning House Condominiums.

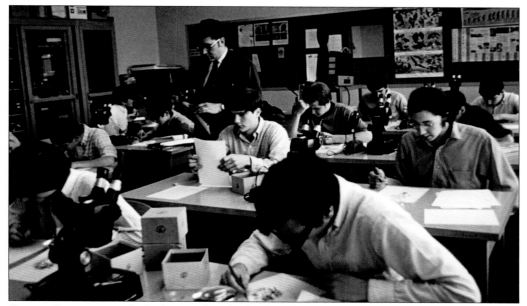

George Cameron taught biology to hundreds of students at Tenafly High School over several decades. It was not unusual for a parent who had Cameron for biology to later attend Back to School Night for their child and be in his classroom again. Microscopes were handled with care under his supervision.

This is a modern view of the earliest school left standing in Tenafly, the Browning School. Built in 1907 for kindergarten through eighth grade, it was designed by William Stoddart and eventually named after a prominent school board member and town benefactor, J. Hull Browning. In 1922, a high school was added to the west, and the tandem schools were used until 1971. The building is now part of the Browning House Condominiums. (Author's collection.)

Pictured is the dedication program for the opening of the "new" Tenafly High School, built on Sunset Lane in 1958. The former high school and Browning School became the junior high school.

DEDICATION

☆ ☆ ☆ ☆ ☆ ☆ ☆ ☆ ☆ ☆

☆ ☆ ☆ ☆ ☆ ☆ ☆ ☆ ☆ ☆

TENAFLY HIGH SCHOOL

TENAFLY · NEW JERSEY

Sunday, May 18th, 1958

The current Tenafly Middle School, below, originally opened as Tenafly High School in 1958. The junior high remained on West Clinton Avenue. On opening day, students left the old high school and walked over to the new building, each carrying their own books.

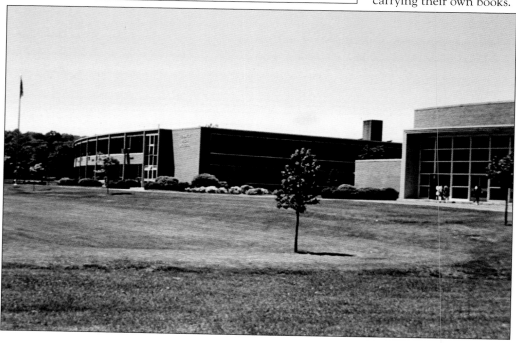

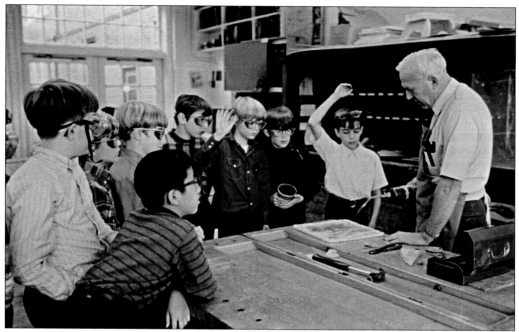

The longtime shop teacher, Herbert Birch of Engle Street, taught for over 40 years at Tenafly Middle School (and at the Browning School before that). Here, he is giving sixth graders a lesson in acetylene in 1969.

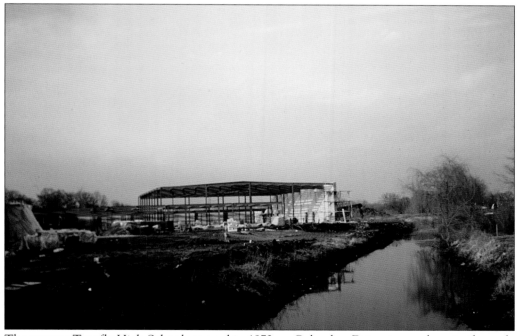

The current Tenafly High School, opened in 1972 on Columbus Drive, is seen here in the early stages of construction. Close to the Tenakill Brook is the part of the building that would include the gymnasium. This photograph was taken in February 1971.

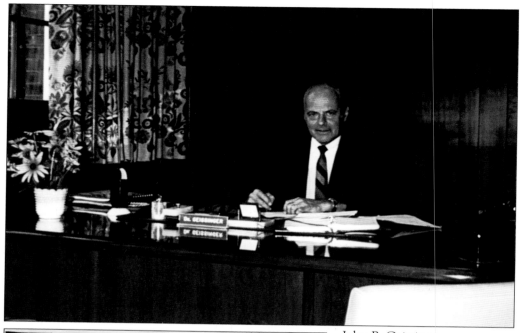

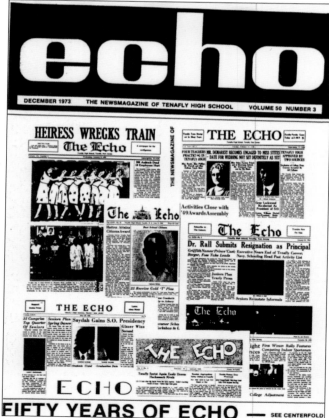

John B. Geissinger was superintendent of the Tenafly Public School District from 1958 until 1976, a time of student population growth, new buildings, and transition. The varsity playing field is named in his honor.

The school newspaper at Tenafly High School has been known as the *Echo* from the very beginning. This is the cover of the 50th anniversary edition in 1973, which shows covers from the first half century of the publication. (Courtesy of Peter Romano.)

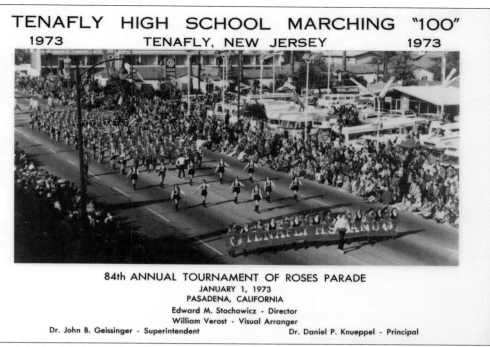

TENAFLY HIGH SCHOOL MARCHING "100"
1973 TENAFLY, NEW JERSEY 1973

84th ANNUAL TOURNAMENT OF ROSES PARADE
JANUARY 1, 1973
PASADENA, CALIFORNIA
Edward M. Stochowicz - Director
William Verost - Visual Arranger
Dr. John B. Geissinger - Superintendent Dr. Daniel P. Knueppel - Principal

One of the highlights in the history of Tenafly was the appearance the high school band made in the 1973 Tournament of Roses Parade in Pasadena, California, on New Year's Day. Funds were enthusiastically raised by parents and students, and the THS Marching 100 was led by band director Edward Stochowicz.

J. Spencer Smith School, built on the former Downey Estate on Downey Drive, opened in 1957 and was named after a prominent member of the Tenafly Board of Education. It was the last of the four elementary schools currently in use in Tenafly to be built.

15

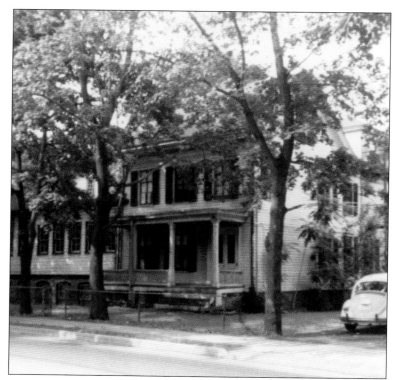

The Rethmore Home (left) on Tenafly Road was used at various times as a summer home for kids, a kindergarten, a Sunday school, and even as a private residence for the Westervelt and Markay families. After falling into disrepair, it was demolished in 1980 (below).

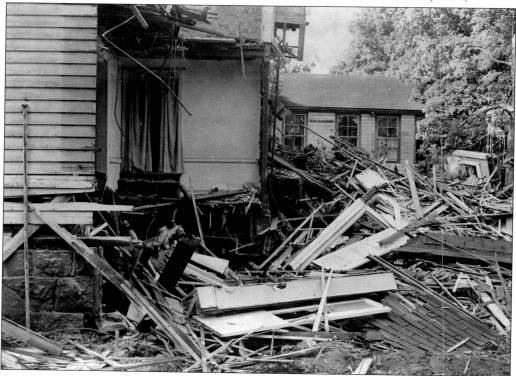

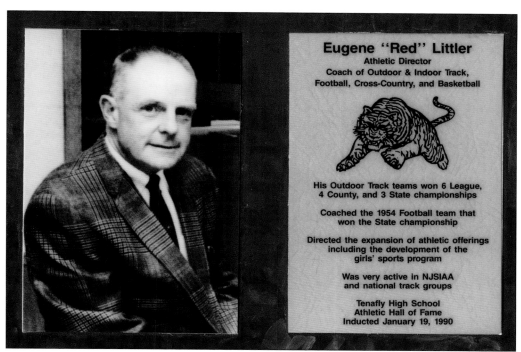

Eugene "Red" Littler
Athletic Director
Coach of Outdoor & Indoor Track,
Football, Cross-Country, and Basketball

His Outdoor Track teams won 6 League,
4 County, and 3 State championships

Coached the 1954 Football team that
won the State championship

Directed the expansion of athletic offerings
including the development of the
girls' sports program

Was very active in NJSIAA
and national track groups

Tenafly High School
Athletic Hall of Fame
Inducted January 19, 1990

A University of Nebraska alumnus and US Army veteran, Eugene "Red" Littler had a huge impact on Tenafly's student body and athletic programs. In addition to leading the Tenafly Tigers to the state football championship in 1954, Littler coached over a dozen track teams to league, county, or state titles. He became vice principal of Tenafly High School before retiring in 1982. The high school gymnasium is named in his honor. (Courtesy of Deborah Littler.)

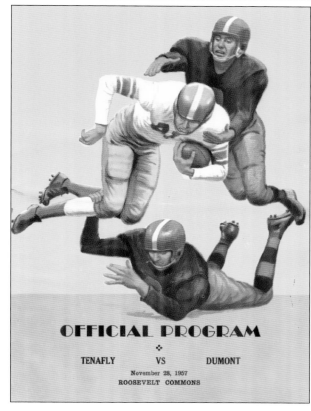

OFFICIAL PROGRAM

TENAFLY VS DUMONT
November 28, 1957
ROOSEVELT COMMONS

The annual football game between Tenafly and Dumont High Schools each Thanksgiving, sometimes referred to as the Turkey Bowl, dates to 1949. This is the cover of the program from the 1957 contest. As of 2015, Tenafly leads the all-time series with Dumont. (Courtesy of Margaret Robbiano.)

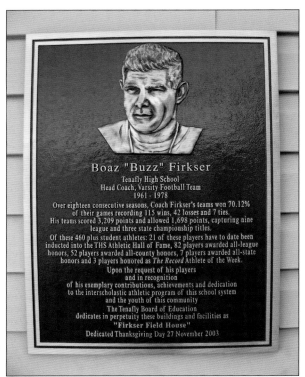

Boaz "Buzz" Firkser

Tenafly High School
Head Coach, Varsity Football Team
1961 - 1978

Over eighteen consecutive seasons, Coach Firkser's teams won 70.12% of their games recording 115 wins, 42 losses and 7 ties. His teams scored 3,209 points and allowed 1,698 points, capturing nine league and three state championship titles.

Of these 460 plus student athletes: 21 of these players have to date been inducted into the THS Athletic Hall of Fame, 82 players awarded all-league honors, 52 players awarded all-county honors, 7 players awarded all-state honors and 3 players honored as *The Record* Athlete of the Week.

Upon the request of his players
and in recognition
of his exemplary contributions, achievements and dedication to the interscholastic athletic program of this school system and the youth of this community
The Tenafly Board of Education
dedicates in perpetuity these buildings and facilities as
"Firkser Field House"
Dedicated Thanksgiving Day 27 November 2003

Boaz "Buzz" Firkser was a longtime athletic faculty member of Tenafly High School. His discipline, with emphasis on teamwork, inspired a generation of football players through what was to become the longest period of the team's success, with nine league and three state group sectional football championships (pre-playoff tournament era). (Courtesy of Sam Bruno.)

The 1962–1963 undefeated Tenafly Tigers football team, led by co-captains John Gibbons and Bill Parmer Jr., are considered one of the best teams in the history of the program. Their exciting 13-7 victory over Hasbrouck Heights was perhaps the key step in reaching the title. The 1962 Tigers are one of only three undefeated and untied squads in the history of the football program. They were inducted as a team into the Tenafly Athletic Hall of Fame in 2016. (Courtesy of Sam Bruno.)

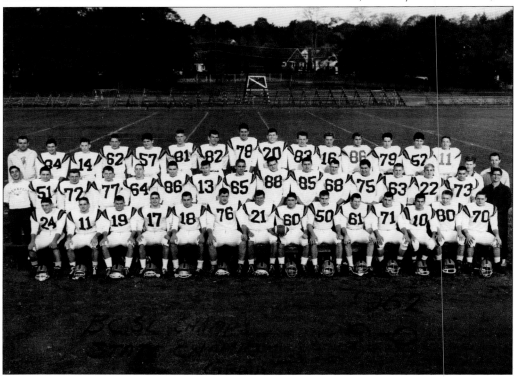

George Nelson followed his successful athletic career in football, basketball, and baseball at Tenafly High School by joining the faculty and coaching staff. Passing up a tryout with the Brooklyn Dodgers, Coach Nelson taught physical education and coached freshman football and baseball at Tenafly High in the 1960s. Shown here kneeling outside today's Geissinger Field, George Nelson passed away in 2011. (Courtesy of Rob Nelson.)

The 1969 Tenafly High School baseball team capped a successful season by posing for their team photograph. From left to right are (first row) Wynn Earnhart, Paul Romano, Ed Rosenthal, Russ Zandonella, Ken Fried, Alan Minetto, and Don Mason; (second row) Jim Wurm, Rich Albom, Brian Bernhardt, Ralph Stanley, Gary Pritchard, and Eddie Harris; (third row) Kevin Coyle, Tom Shadek, Ken Kaplove, Jim Schuman, and Jeff Saams.

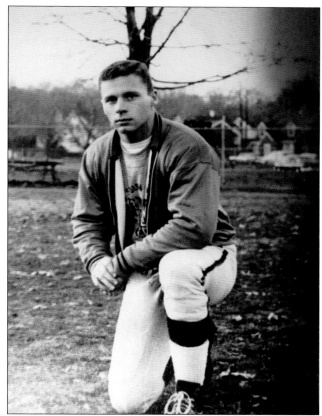

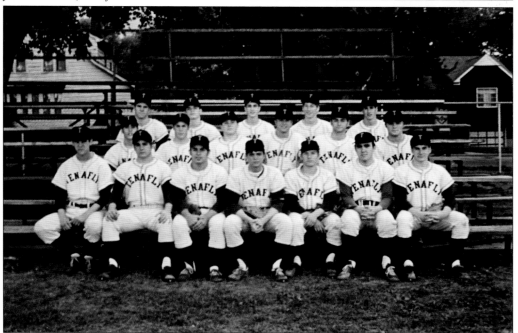

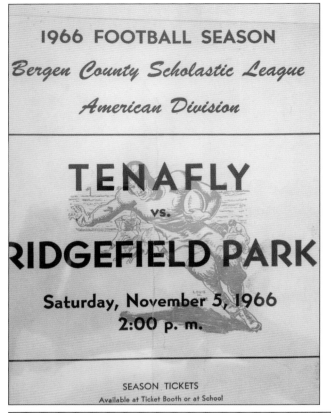

1966 FOOTBALL SEASON

Bergen County Scholastic League

American Division

TENAFLY

vs.

RIDGEFIELD PARK

Saturday, November 5, 1966

2:00 p. m.

SEASON TICKETS
Available at Ticket Booth or at School

This is a program typical of those given out at Tenafly High School football home games. This particular game against league rival Ridgefield Park was notable for the appearance at the game by entertainer Ozzie Nelson, former Tenafly resident yet Ridgefield Park alumnus. He chose to sit on the sideline . . . of the Tenafly Tigers. (Courtesy of Rob Nelson.)

Jack Hajinlian was the father of Tenafly's junior soccer program. Shown coaching here behind the middle school (later the high school) in 1967, Hajinlian ran the league and attended most games, cheering all the kids on well past his years as a coach. (Courtesy of David Sokol.)

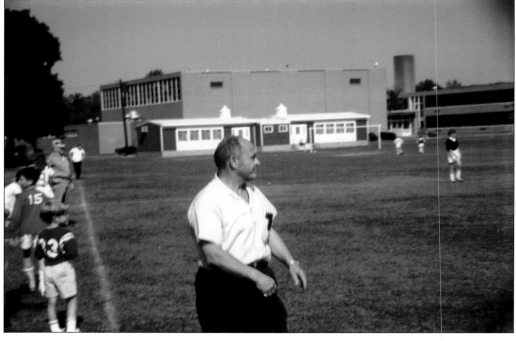

Tenafly's summer recreation program for kids, now known as Recky's Camp, is an annual six-week program that has been popular in town for decades. It used to take place in several parks concurrently. Here, councilor Bill Jaeger discusses the day's activities with the gang at Mackay School in the late 1970s. (Courtesy of Louis Dotti.)

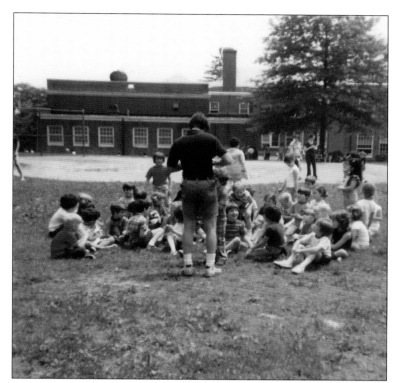

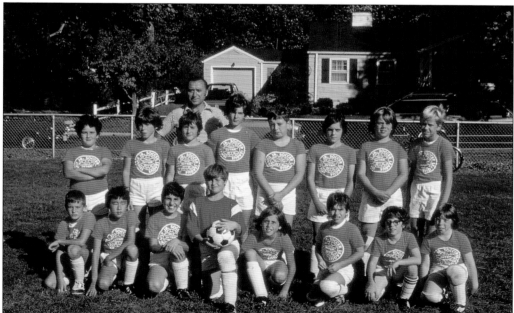

Many Tenafly residents who had children growing up in the 1970s and 1980s have soccer team photographs like this. The Tenafly Junior Soccer League boomed. This is the Orange intermediate team at Sunnyside Field in the fall of 1973. The coach was Nick Pituras. (Courtesy of George Pituras.)

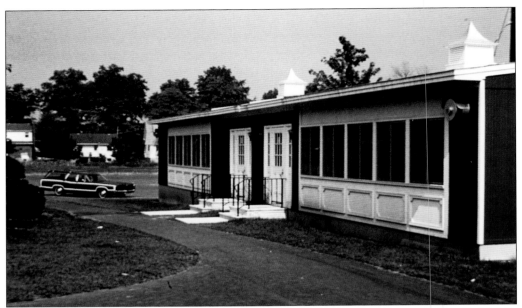

In the years following the construction of the Sunset Lane High School (currently Tenafly Middle School) in 1958, trailers were used as supplementary classrooms. The environment in these detached classrooms often lead to some interesting situations—bees, snowballs, too much heat, too little heat, and wet carpets. Shown in this late 1960s photograph are trailers seven and eight, which stood closest to the Tenakill Brook. The trailers finally came down in the mid-1980s, but one is still in use on the Department of Public Works (DPW) property.

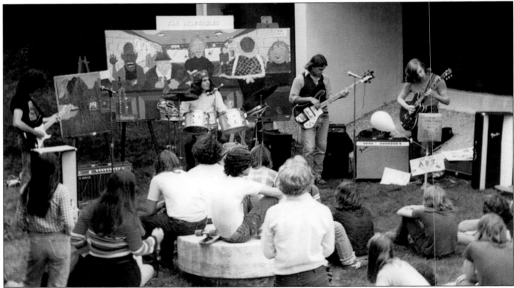

The Burnt Vegetables were a local band made up of young musicians from Tenafly and Englewood in the mid-1970s. Their gigs were popular among students, including this show they put on outside the Englewood Library in 1977. Today, they occasionally perform a song or two in some form, and continue to record music. Pictured here from left to right are Paul Wilder, Jimmy Faivre, Keith Faivre, and David Grossman. (Courtesy of Jimmy Faivre.)

Two

THEY SERVE OUR TOWN

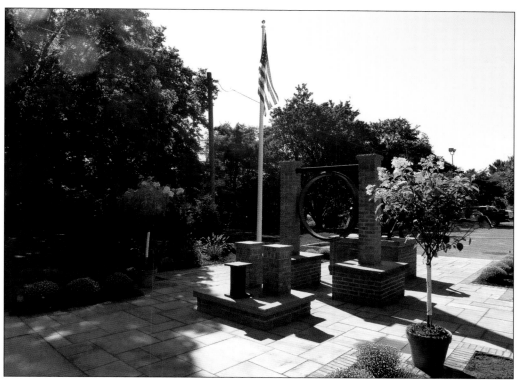

The Fire Department 9/11 Memorial, in front of the current firehouse, was designed by local architect and lifelong resident Tom Swift in 2013. The original fire bell from Tenafly Hall on Jay Street is in the back and can be seen through the fire ring from the first 1890s firehouse on West Clinton Avenue. In front is a portion of beam from the World Trade Center secured for Tenafly by Councilman Tony Barzelatto in 2012 to memorialize those who lost their lives in the attack. (Author's collection.)

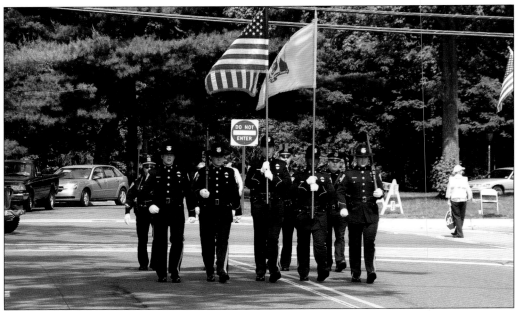

Representing Tenafly's finest at town events and celebrations is the Tenafly Police Honor Guard. Here, they are marching in the 2008 Memorial Day Parade. They perform a 21-gun salute each year during the ceremonies honoring lost veterans.

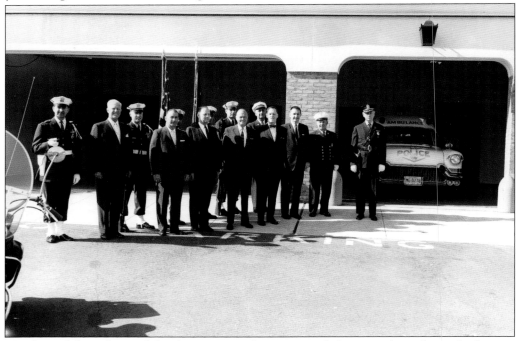

Members of the police and fire departments, the mayor, and the council stand outside the new fire department in the mid-1960s, not long after the new Municipal Center was finished. Lined up in front are Police Chief Campbell (far left), Mayor Shull (second from left), and Fire Chief Leahy (second from right).

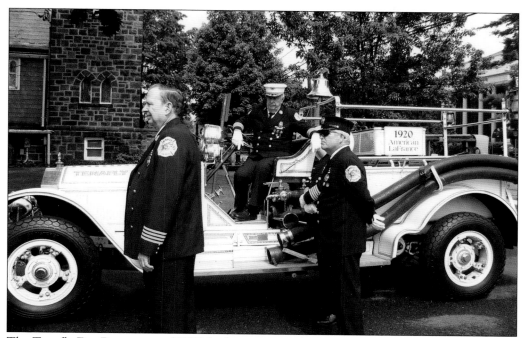

The Tenafly Fire Department (TFD) broke new ground when this American LaFrance pumper was purchased in 1920. Still making appearances for parades and events, it is driven here by 50-year TFD member Ted Arzonico, with Alden Blackwell in front and Tom Swift behind. (Author's collection.)

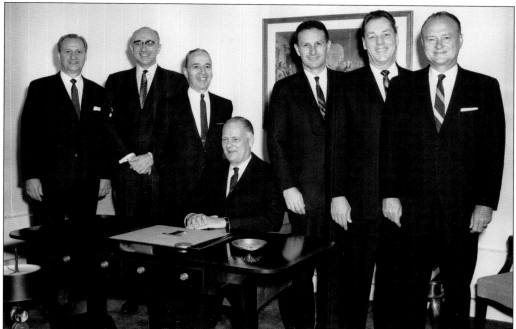

Mayor Richard Shull (seated) and the council are pictured in the mid-1960s. Paul Bollerman, far right, would succeed Shull as mayor in 1968.

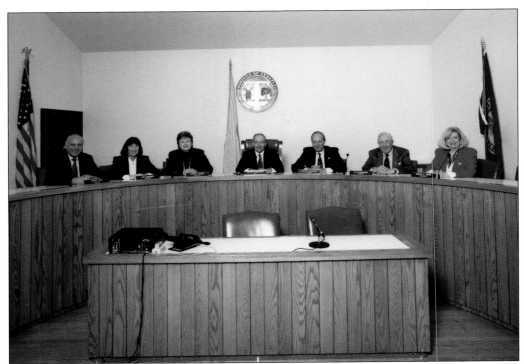

The 1993 mayor and council are shown in the dais above. From left to right are Edward Deeb, Judy Armaniaco, Lenore Saydah, Mayor Walter Hemberger, William Saunders, G. Lott Nostrand, and Martha Kerge. Below, flashing back 30 years, is the 1963 planning board seated in the conference room at Borough Hall.

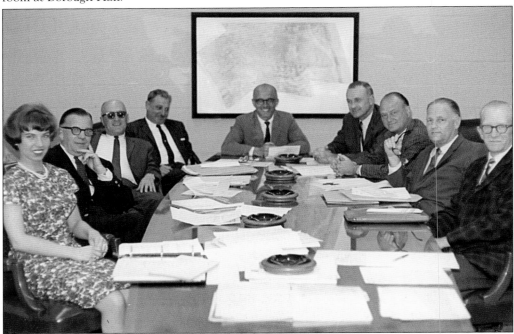

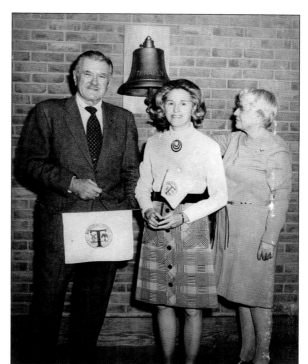

At right, Walter Hartung (left), mayor of Tenafly in the 1970s, shows off a flag and banner with the Tenafly seal. In the background is a bell from the old steamboat *Tenafly*. Below, Ann Moskovitz, who would later be mayor, holds her design for the centennial seal for the 1994 town celebration.

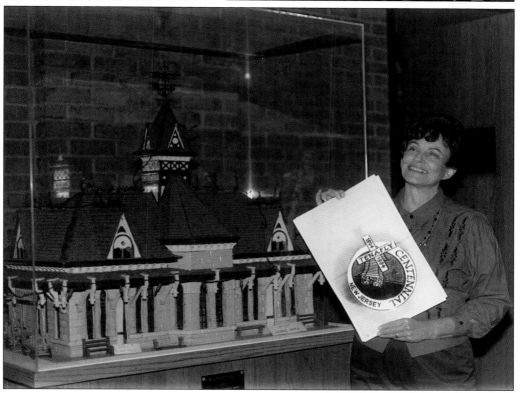

Mayor Richard Van Nostrand first took office in 1979, after years as a councilman. He was mayor from 1979 through 1991, when his untimely death occurred months before he was scheduled to retire. Shown here in the 1960s, Dick Van Nostrand left his mark on the borough, and the gazebo at David Johnson Park is dedicated to him.

Mayor John Manos and Councilman Bruce Baker present an anniversary gift to a borough employee. This photograph was taken in the late 1970s, near the entrance to the council chambers, which looked then as it does now.

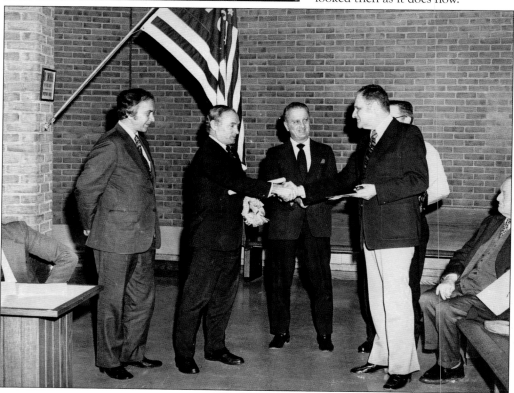

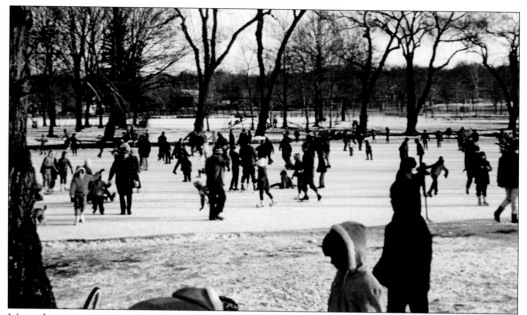

More than one generation of residents will remember the pond at Roosevelt Common as an active place to ice skate. To keep the ice thick enough, a member of the fire department would drag a hose across Riveredge Road and periodically wet the pond. This prevented the need for the "no skating allowed" sign to be displayed.

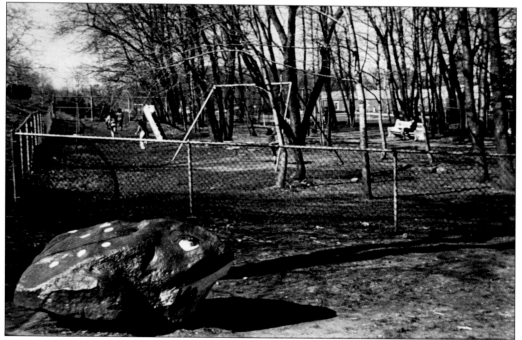

Froggy Park is pictured here in the 1960s. A mainstay for parents to take tots for the jungle gym or just to run around, all were greeted by this painted rock of ideal size. It is believed that the rock was first painted by Boy Scout Troop 86.

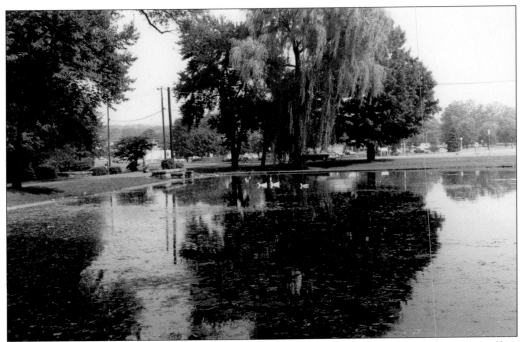

The Roosevelt Common pond and the view around it have evolved over the years. Above is the willow tree–laden look of the 1970s, when the pond had a cement border. (Author's collection.)

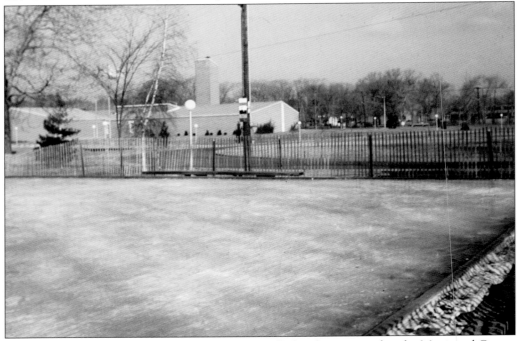

For several years in the 1960s, an ice rink was installed and maintained at the Municipal Center near the library. John Redfield, a benefactor of many recreational facilities in town, consulted on the project.

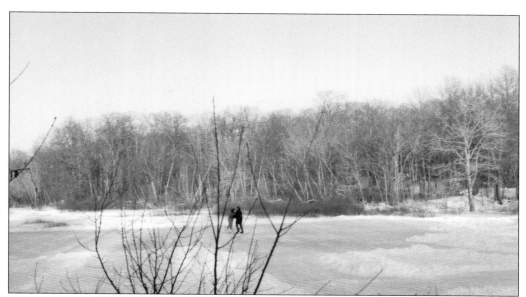

Two lone skaters have Pfister's Pond at the Tenafly Nature Center to themselves. The pond, named for a Hudson Avenue resident of the 1920s and 1930s, is the centerpiece of the town nature preserve and learning center that spreads over 300 acres.

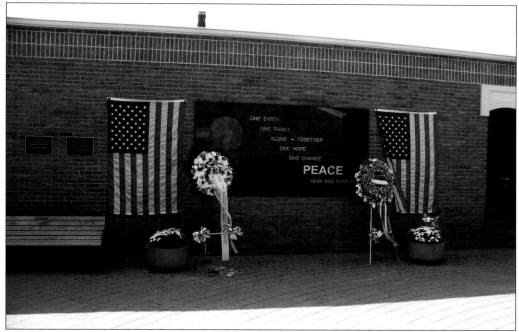

Peace Plaza, built in 2001, was constructed to honor the memories of former borough administrator Robert Miller and his wife, Betty, who were lost in the TWA Flight 800 crash in July 1996, as well as a tribute to world peace. Two days after the ceremony, the tragic events of September 11, 2001, shocked the borough and claimed the lives of four residents. Peace Plaza was rededicated in tribute to them for its 10th anniversary in 2011. Wreaths are placed in Peace Plaza each year on September 11. (Author's collection.)

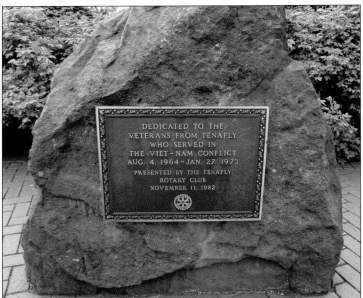

More than 40 Tenafly residents served in the Vietnam conflict. Fortunately, almost all returned home safely, but one Tenafly High School graduate, John Kapeluck from Cresskill, was mortally wounded in 1967. This plaque was dedicated to the Vietnam veterans in 1982 by the Tenafly Rotary Club. The monument originally stood in the common but is now located in Huyler Park. (Author's collection.)

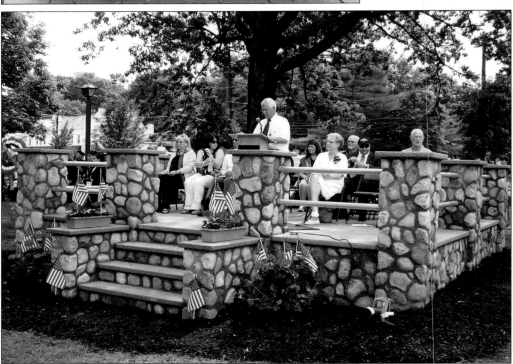

The renovated bandstand at Huyler Park was dedicated for Memorial Day 2011. It replicated the design of the original 1909 bandstand built by local masons Arzonico & Benzoni. Carl Passera Jr. constructed the new one based on plans secured by his father after a citizen group raised the funds privately for it. Here, Mayor Peter Rustin speaks at the bandstand's opening day. Alice Rigney, who spearheaded the fundraising committee, and Joe Benzoni, nephew of the original builder, are at right.

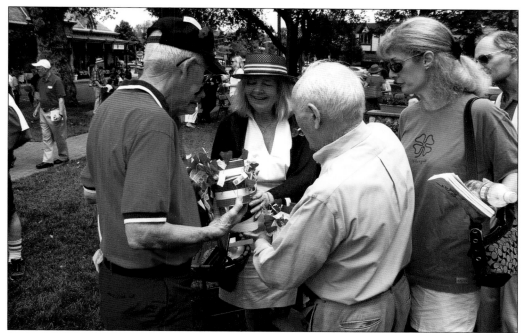

Although the Tenafly American Legion disbanded 25 years ago, the distribution of poppies for donations on their behalf continues. Rich White, Liz Shanks, former councilman Bruce Baker, and Joanne Stefanowicz share in the duties.

Members of the Tenafly Lions Club supervised the erection of the creche and other holiday decorations in Huyler Park. Lifelong resident and Demarest family descendant Tom Swift, second from right in the hat, continues to serve the community to this day.

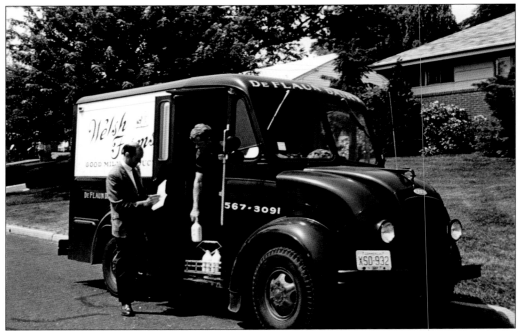

Who lived in Tenafly when it still had milk delivery? This 1968 photograph shows a deliveryman from DeFlaun distributing freshly bottled milk from Welsh Farms.

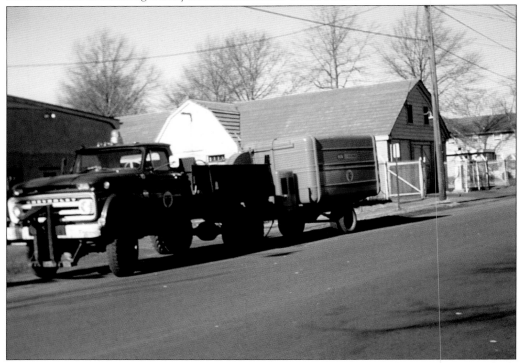

This 1984 view shows the DPW facility as it looked over 30 years ago. The new structure, built in 2016, replaced a conglomeration of smaller buildings and trailers.

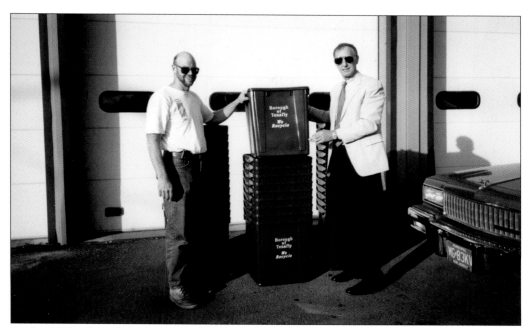

By the 1990s, Tenafly had joined area communities by putting recycling programs in place. The blue recycling boxes for commingled items made their debut in 1994. Former DPW chief Bob Beutel is pictured at left.

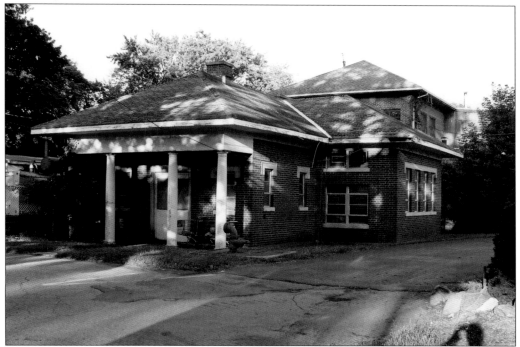

The pump house was built in 1927, originally housing the power supply for the town's sewage processing. Once Tenafly's sewer line was no longer standalone, this building functioned as an office and storage for the recycling center, until it was demolished about 2011.

Ralph Van Sickle was a drafting teacher for much of his academic career instructing Tenafly students. Later, he worked with the Red Cross and taught CPR to a second generation of students.

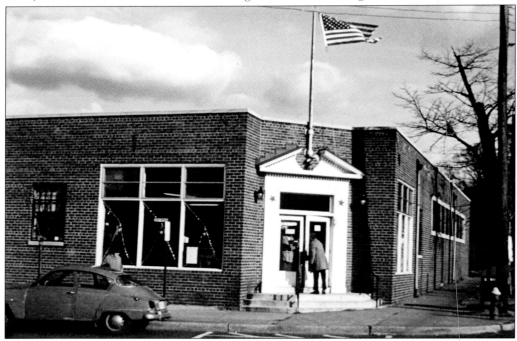

In the 1950s and 1960s, the Tenafly Post Office was located at the northwest corner of Jay Street and County Road (pictured). Despite its attractive entrance, the site became too small, and the post office was relocated to its current site on Tenafly Road in 1971. This building was recently a School of Rock, part of a chain of music schools.

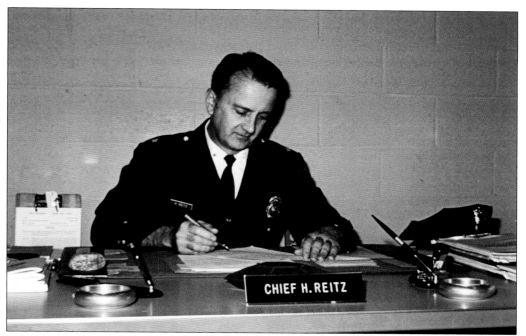

When Police Chief Henry Reitz took over from 40-year veteran Chet Campbell in the 1970s, it was the pinnacle of a long journey. Policemen in Tenafly used to greet arrivals at the train station, lift and lower the gate at the rail crossing, and supervise lighting downtown. Reitz traveled that path and led a modern force.

The recycling and exchange facility will always be affectionately called "the Dump" by residents. It used to have a smokestack, and incineration once took place at the facility.

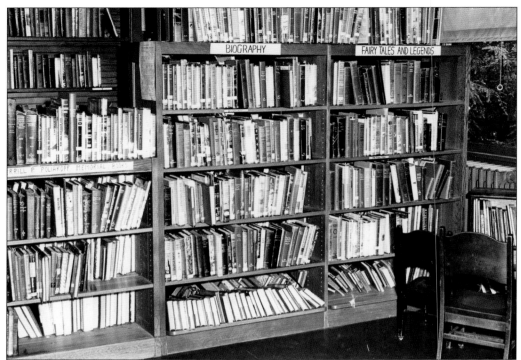

The biography section of the old library on Washington Street shared a bookcase with fairy tales. In 1912, the former post office building was bought by the Library Association for $1 and moved to the location where it stood for 50 years, on the lower portion of the south side of Washington Street.

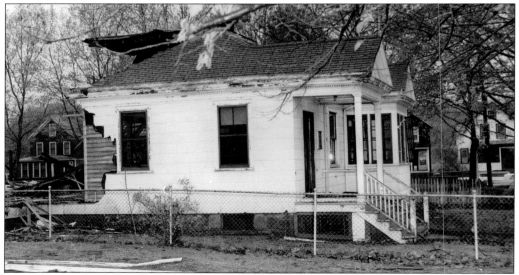

While the first 50 years of Tenafly saw construction of a library and Borough Hall on Washington Street, the 1960s saw their demolition after the new Municipal Center was built between 1961 and 1962. On a cold rainy day in 1963, after countless additions and renovations over the decades, the original Tenafly library came down.

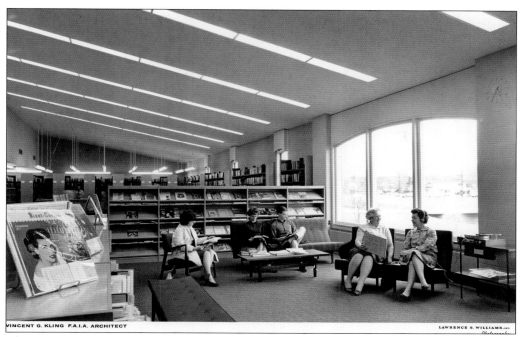

VINCENT G. KLING F.A.I.A. ARCHITECT LAWRENCE S. WILLIAMS, INC.

This 1960s view shows the original layout of the current library. The sitting area and listening station are in the foreground. Behind those were reference and periodicals. Today's library has been expanded where the window is seen here.

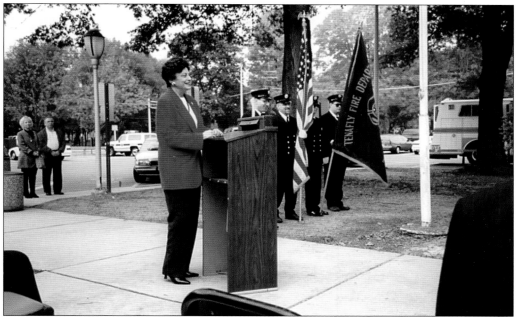

Mayor Ann Moskovitz, seen here addressing the fire department at a ceremony in 1997, was mayor from 1996 to 2004. She took an active role in the League of Women Voters, as well as the 1994 Tenafly Centennial Committee. Moskovitz has been the borough's only woman mayor to date. She oversaw the ambitious Y2K Downtown Renovation on her watch.

The Teen Center, or Youth Center, has been located around town in various places, such as the Presbyterian church school building and the old junior high school (also known as Browning House) on South Summit Street. Its current home is annexed to the Municipal Center. Construction is pictured here in the 1990s.

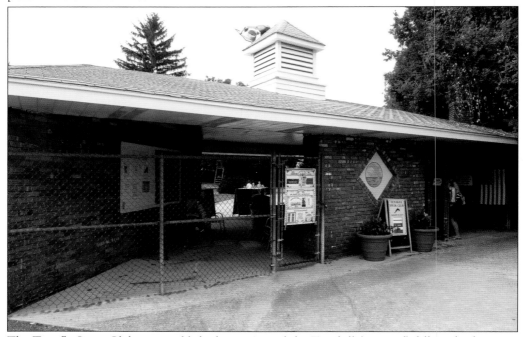

The Tenafly Swim Club was established in 1961, and the Tenakill (pictured) followed a few years later. These clubs served generations of families and occupied kids on many hot summer days. Tenafly Swim Club closed its doors in 2015, while the Tenakill continues to thrive. (Author's collection.)

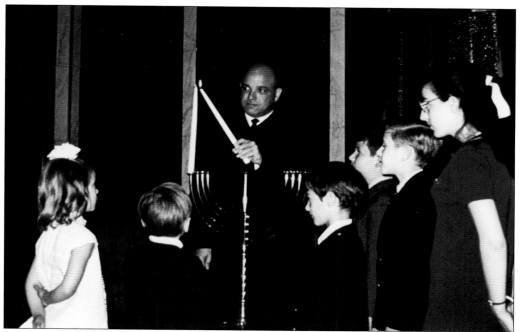

An early Hanukkah at Temple Sinai is shown here. The building, which was expanded in the 2000s, opened in the late 1950s. This photograph was taken in the mid- to late 1960s.

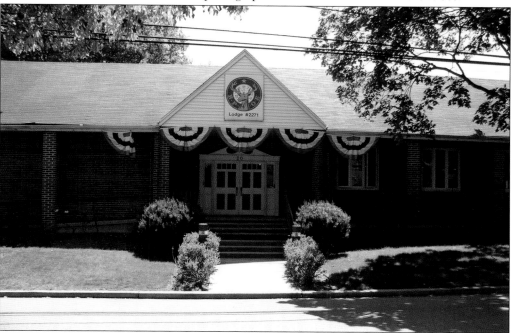

The Tenafly Elks BPOE 2271 goes back several decades. Previous to that, Tenafly members went to the Elks Club in Englewood. After the American Legion, with which the Elks shared a facility, closed, the Elks building was fully renovated and expanded in 1987. Its membership keeps brotherhood and sisterhood alive, and they perform many charitable deeds. (Author's collection.)

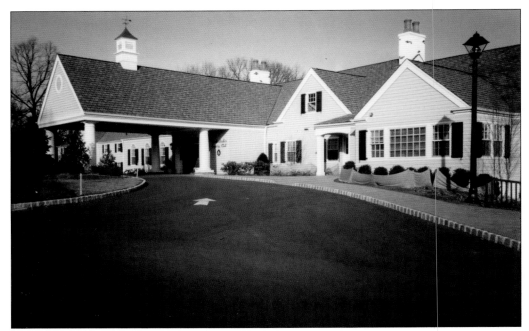

The Knickerbocker Country Club, established in 1914, celebrated its 100th anniversary in 2014. The front of the clubhouse has changed little over past decades, but there have been additions in back and a total renovation on the interior. This photograph was taken about 1970.

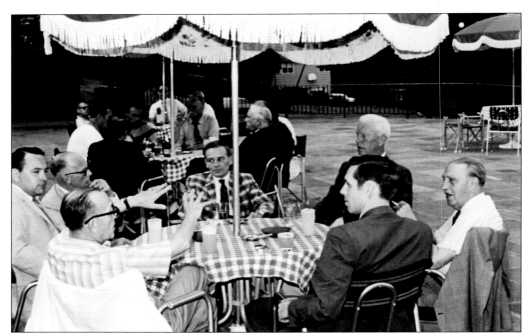

Summertime at Knickerbocker Country Club meant sitting outside on the patio behind the clubhouse. This 1970 photograph shows members enjoying the warm weather and discussing issues of the day.

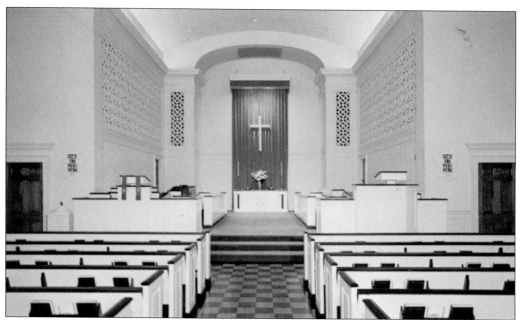

In the early 1950s, the Presbyterian church at Tenafly realized that the historic stone church had become too small to hold services. Here is a 1953 view of the interior of the current church, soon after construction was completed.

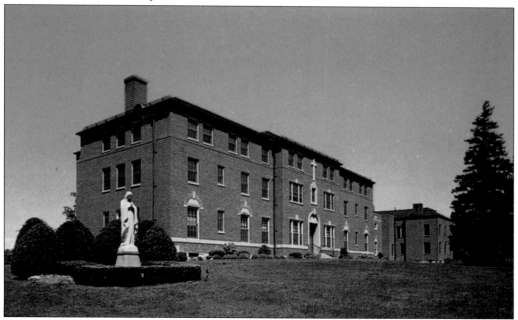

This convent, seen in the 1950s, is home to the Missionary Franciscan Sisters of the Immaculate Conception. Many residents are retired nuns, who profess vows to "universal compassion through inclusive non-dominating relationships of love." Sister Mary Victor Waters, a resident of the convent, made news recently when she celebrated her 109th birthday, having only retired from active service at age 97. The gift shop is popular among locals and keeps the sisters active t.

In 2015, St. Thomas Armenian Church of Tenafly celebrated the 50th anniversary of its consecration, which took place on April 4, 1965. Rev. Father Arnak Kasparian was the first parish priest of this new building. St. Thomas was the first Armenian church to serve Bergen County residents.

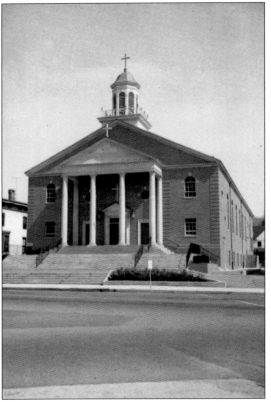

When the new Mount Carmel church was built, the orientation was changed to face County Road; the original structure faced Hillside Avenue. Note the old rectory to the right.

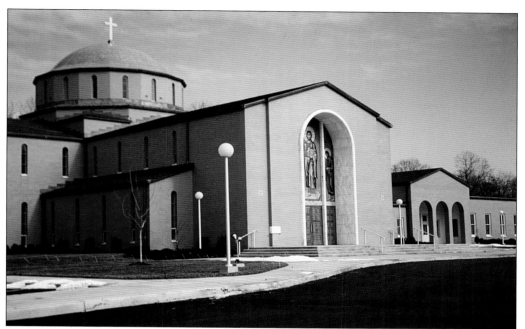

In 1969, St. John the Theologian Greek Orthodox Church (now Cathedral) opened. This was a result of years of donations and hard work by its parish and benefactors. Pictured is the church when new, soon after its dedication.

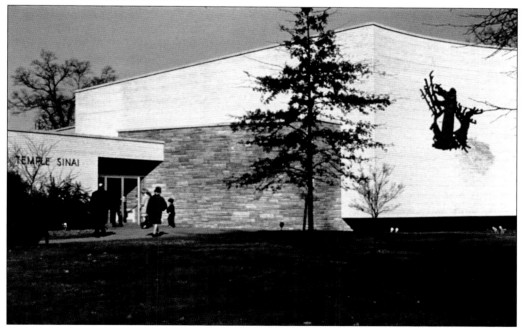

Five families sponsored a meeting with the American Union of Hebrew Congregations in May 1952. The idea blossomed into a thriving community action, and Temple Sinai was built in 1958. The nationally accredited preschool, which flourishes today, began in 1977. The facility was expanded in the 2000s.

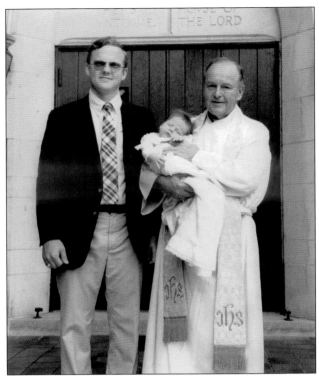

The Rev. Henry Powers led Tenafly's Church of Atonement from 1954 through 1979. Reverend Powers believed in meeting members of the parish on a personal level and made 628 house calls or sick calls over his first 18 months in Tenafly. At left, he is baptizing his grandson David, while his son Dave Powers looks on. Below is the historic Tenafly Church of Atonement in all its recent glory. The parish dates to 1868. (Left, courtesy of Betsy Powers Hodges.)

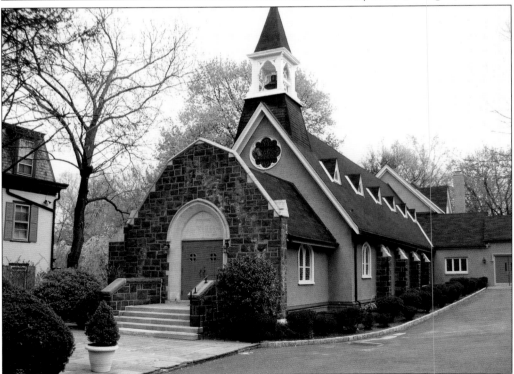

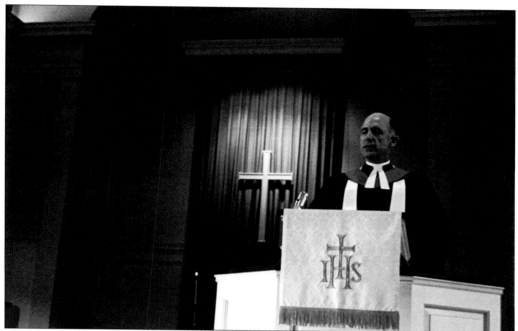

Rev. Harry Chase was pastor at Presbyterian Church at Tenafly for over 20 years, dating to the 1960s. Under his vision, the parish grew to its largest membership.

The Municipal Center is pictured soon after its completion. It was built on property that was part of the former Lyle Estate. The area with many trees that can currently be seen across from the post office, later named after Sgt. Nicholas Oresko, was only newly planted in this mid-1960s photograph.

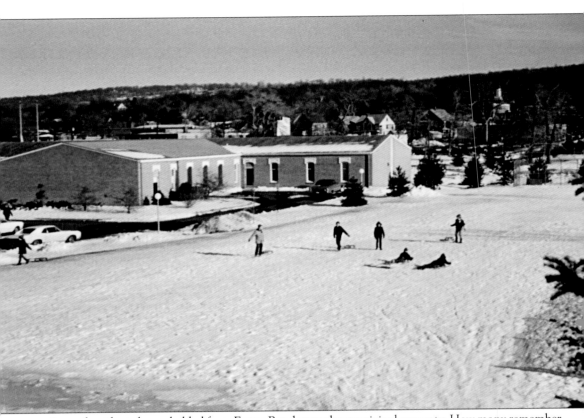

Lots of residents have sledded from Foster Road onto the municipal property. How many remember when a good packed snow would allow sledding all the way down across the municipal field? This photograph dates to the early 1970s.

Three

EVENTS AND CELEBRATIONS

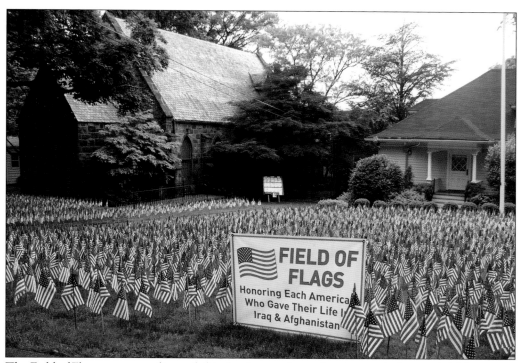

The Field of Flags was a traveling exhibit that honored men lost in wars in Iraq and Afghanistan. Each flag represented a lost soldier. In 2010, the Tenafly Presbyterian Church hosted the event in time for Memorial Day and quite an impressive feature it was in front of the historic chapel and church house. A total of 5,481 flags were placed for the exhibit.

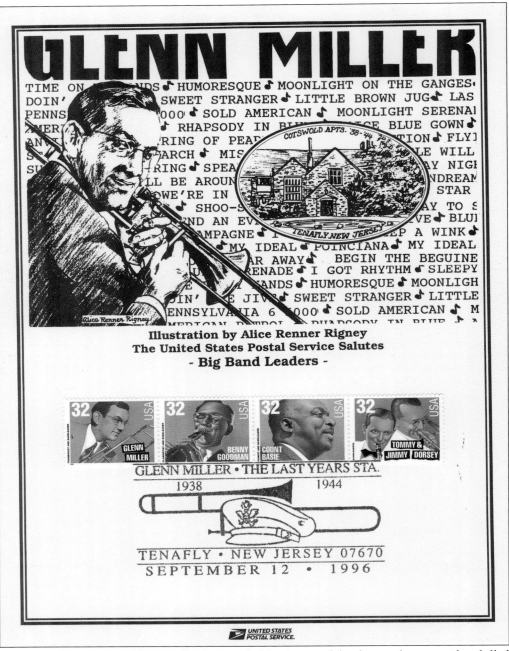

On September 12, 1996, Glenn Miller Day was held in honor of this famous former resident killed during World War II. A second-day issue for a set of stamps that included one for Miller was offered on this commemorative sheet designed by Tenafly artist Alice Rigney. (Author's collection.)

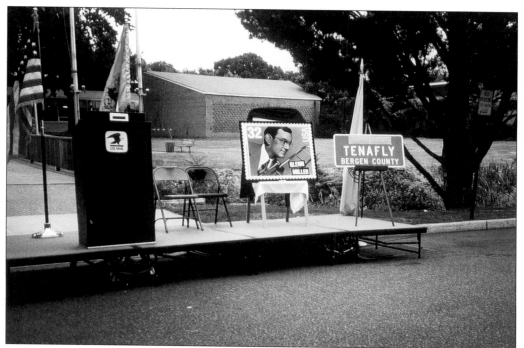

Musical performer and bandleader Glenn Miller, shown on the 1996 US Postal Service stamp issue, is honored each year on Memorial Day, as his plane was lost during World War II while his family lived in Tenafly. Below is the Cotswold estate, a building on Byrne Lane in which the Miller family had an apartment.

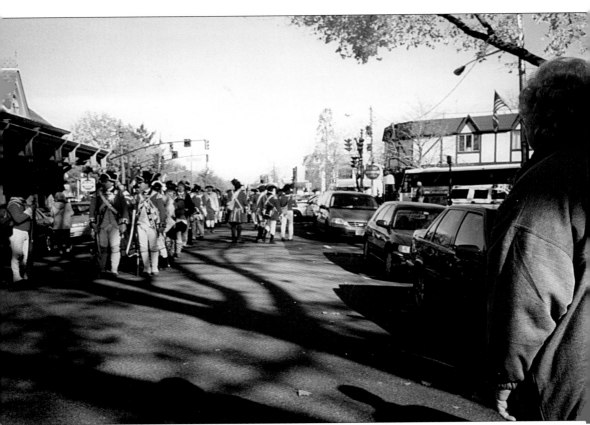

British troops marched through what is now Tenafly in November 1776 on their way to attack Fort Lee. In modern times, reenactments of these events have given residents the opportunity to see replica uniforms and muskets and hear stories of historic lore. This reenactment took place outside the railroad station in 1995.

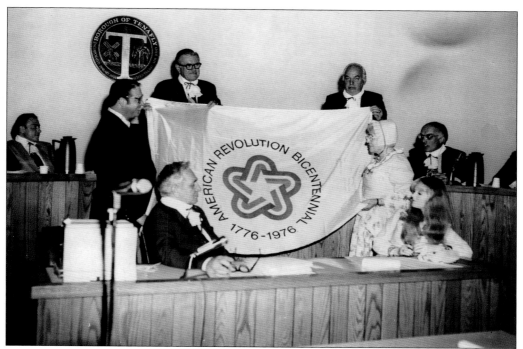

The mayor and council are pictured above dressed in period clothing on the night the bicentennial flag was unfurled in council chambers in 1976. Walter Hartung and Dick Van Nostrand stand above the flag, while historian Virginia Mosley and Lou DiPaolo stand to the right. Below, in the same location, the New Jersey tercentennial flag was displayed in 1964.

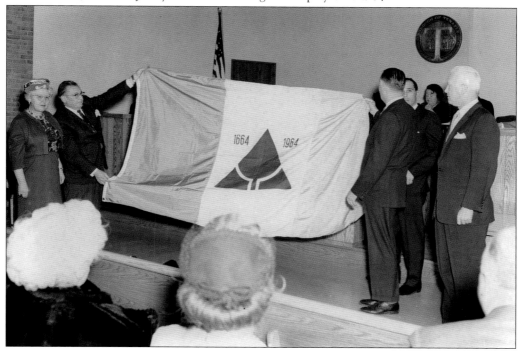

The DeWitt Coleman VFW Post 167 was named for one of Tenafly's valiant casualties of World War I. VFW Post 167 celebrated its 50th anniversary on May 14, 1969, with dinner at the Clinton Inn. Early members are, from left to right, Bill Mowerson, Louis Taras, Clinton Taveniere, Norman Graham, and Lloyd Winnell.

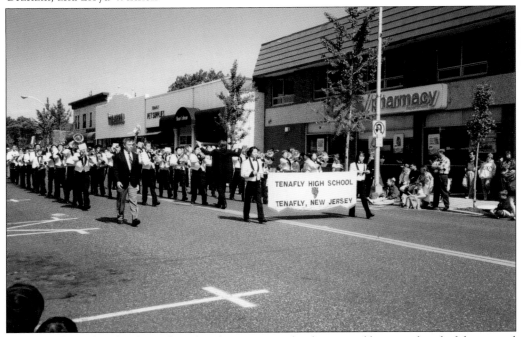

The Tenafly High School marching band continues to be the musical heart and soul of the annual Memorial Day Parade. They also perform the national anthem and "Taps" during the ceremony at Huyler Park to honor area veterans. This photograph was taken in the mid-1990s.

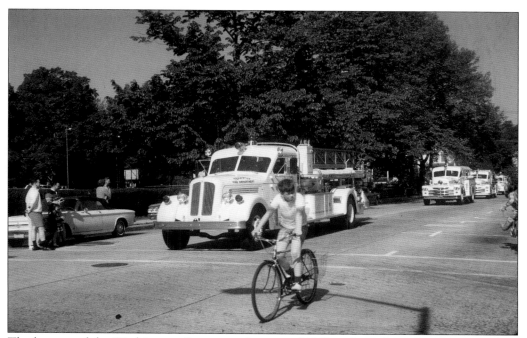

The bottom of the Washington Street parade route of 1969 is shown here. Residents stood on the west side of Tenafly Road then and still do today. Some of these fire vehicles still take part in the annual Memorial Day Parade, and this part of the route remains the same.

Over the past 20 years, the annual sidewalk sales, held every July, have morphed into the street fairs held each spring and for Oktoberfest. This gives visitors the opportunity to see the fair's vendors and games but experience the local stores and restaurants downtown as well.

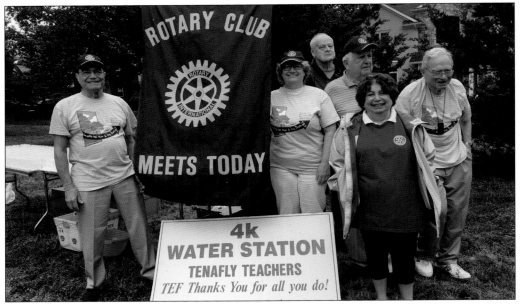

The Tenafly Rotary Club volunteers staff a water table at the annual Tenafly 5K Run and Dog Walk, which benefits the Tenafly Educational Foundation. From left to right are Jon Warms, Christine Evron, Fred Crabbe, Gerry Kotch, Berni Koch, and Ed Dollinger. The Rotarians reported that no runners have ever collapsed within their water field, and dogs have been seen lapping up the water. (Courtesy of Jon Warms.)

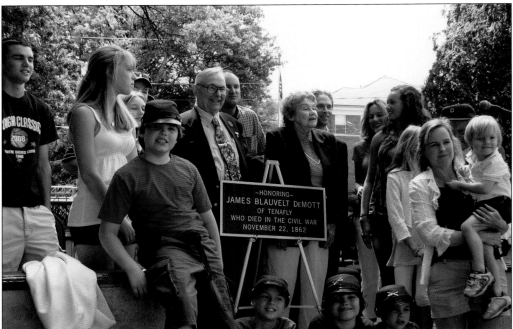

Descendants of the DeMott family gather on the bandstand after a ceremony took place honoring their ancestor James Blauvelt DeMott, who died in the Civil War in 1862. The plaque that was unveiled that day is now on the war memorial monument in Huyler Park. (Author's collection.)

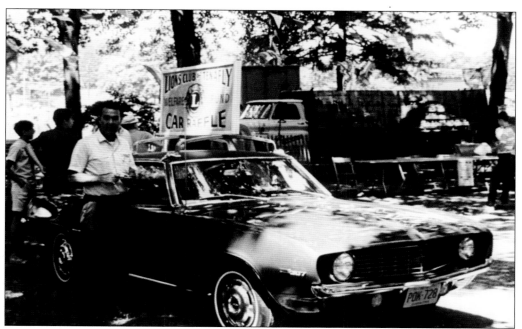

A car raffle sponsored by the Tenafly Lions Club was the main attraction at the Fourth of July celebration in the Roosevelt Common each year. Rides, straw hats, and ponies were present, as tickets picked up at the Municipal Center from the recreation department gave kids options for holiday fun. The event still takes place today.

In 1969, the borough of Tenafly celebrated its 75th anniversary. A banquet at Tammy Brook Country Club capped off the celebration. Anniversary books were distributed to all households, and original founding residents, many of whom were in their 80s and 90s, were honored.

During the holiday season, many stores in the downtown had their windows decorated—some by employees and others by students. Part of the window-shopping experience for years was looking at all the stores' Christmas exhibits. Above is a 1960s exhibit at Tenafly Department Store, and below is a photograph of the Cooktique display on West Railroad Avenue in the 2000s.

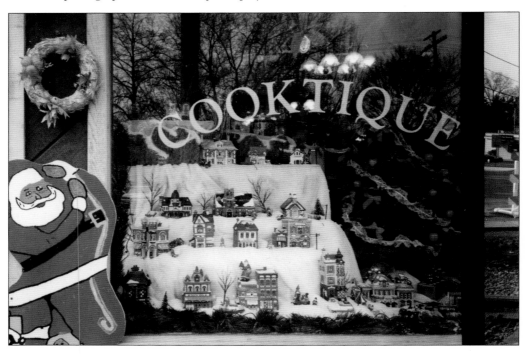

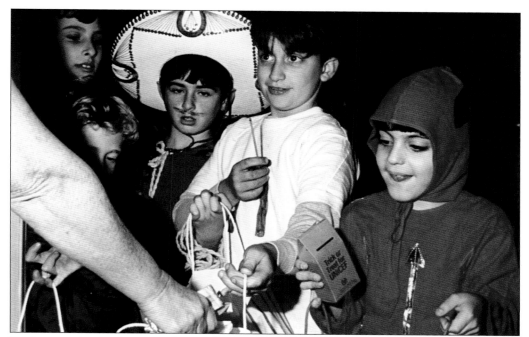

Trick or treating is a long-standing tradition in Tenafly, as it has been for generations all over the United States. These kids were having fun while collecting for UNICEF on Halloween in 1968.

Huyler Park is decorated every year for the holidays. The historic railroad station is visible behind this 1960s display. Live sheep were kept in a separate pen, away from the singers.

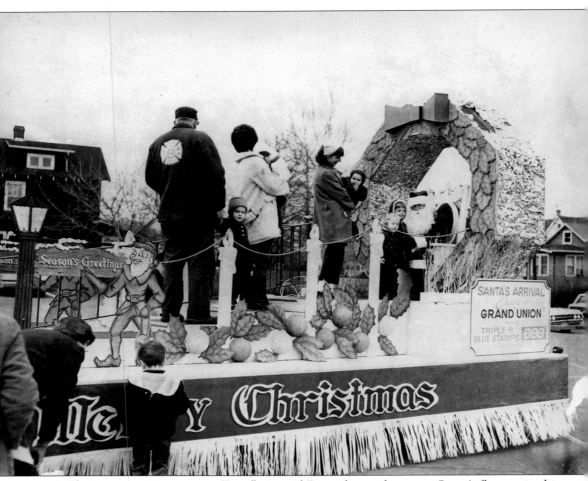

A Christmas preview came to Tenafly in mid-December each year as Santa's float arrived in the Grand Union parking lot. Kids looked at the elves and decorations as they lined up to meet St. Nick. Santa seemed to approve of any late gifts being purchased using Triple-S Blue Stamps, which happened to be available inside the Grand Union supermarket.

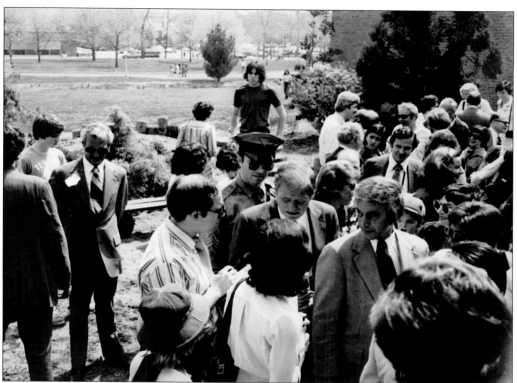

In 1976, while Tenafly's administration was fighting to keep open space land on the east hill protected from development under the Green Acres program, Gov. Brendan Byrne visited Tenafly. Above, he is shown meeting with residents and officials outside of Borough Hall. Below, the 185,000 square-foot Kaplen Jewish Community Center on The Palisades, made possible by the effort to preserve the east hill property, thrives as an important part of Tenafly.

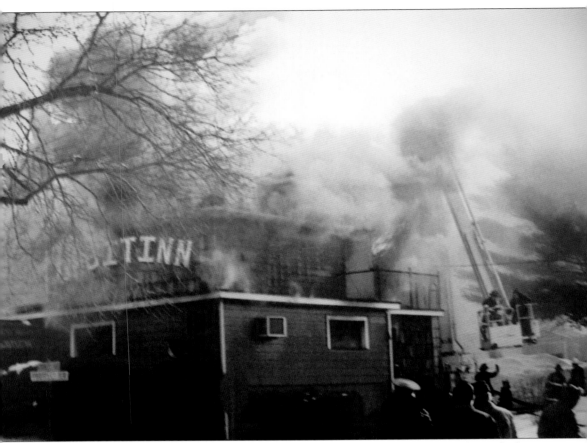

In February 1978, a fire destroyed a local saloon called the Orbit Inn. It was the end of an era, as a generation of young people had gathered at "Orbit Al's" establishment. (Courtesy of Mike DeAngelis.)

Four

LOCAL BUSINESSES AND PERSONALITIES

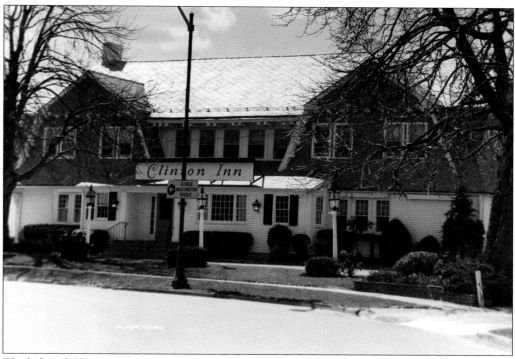

The beloved Clinton Inn is seen here in the 1960s. The building was constructed in 1908 after the previous structure burned down. The Chagaris family bought the inn in the late 1940s, eventually adding a modern Clinton Inn Motel behind it. This building was demolished in 1978.

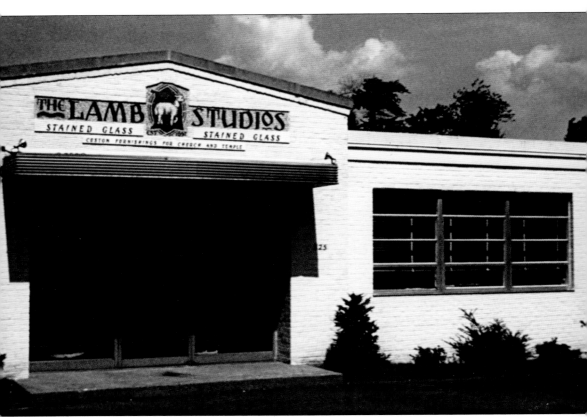

Col. Karl B. Lamb (1890–1969) decided to move the Lamb Studios stained-glass company from Manhattan to West Clinton Avenue in Tenafly in 1932. The company produced fine artistic stained glass for churches and buildings both near and far for almost 40 years in Tenafly. From 1956 through 1970, the firm operated out of this County Road building, which still stands.

The Clinton Inn Hotel, formerly the Motor Lodge, in its current form, is where many high school reunions are held. Above, the Tenafly High School class of 1963 celebrates its 50th reunion in the downstairs hall. Below is what the Motor Lodge looked like when first built in 1968. Note there used to be houses where the parking deck now stands.

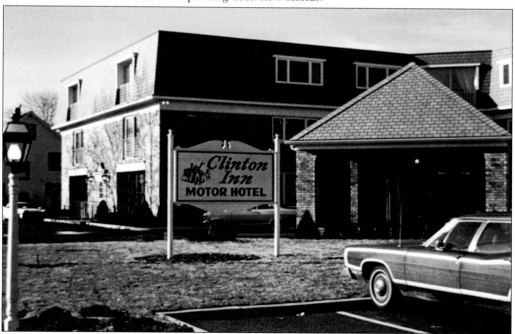

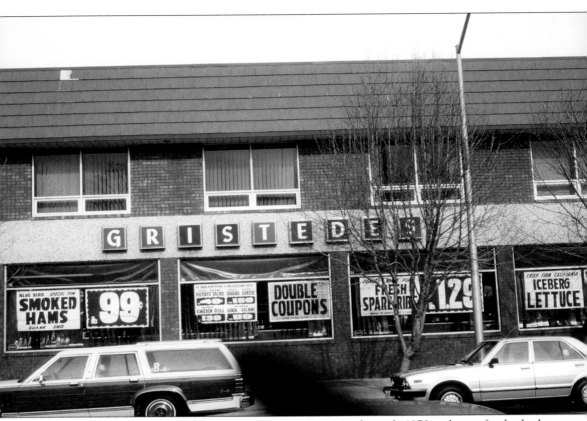

Gristedes grocery store was built on Washington Street in the early 1970s, where a fire had taken out several stores. This grocery chain was known for its intimate atmosphere and emphasis on service and fresh produce. This is now the location of the Tenafly CVS.

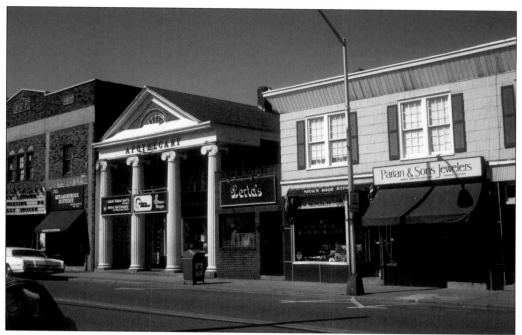

Tenafly's quaint downtown, which runs along West Railroad Avenue (above) and Washington Street (below), has featured many popular stores important to Tenafly. The apothecary (formerly the K.B.C. Smith Building), with its familiar pillars, borders the old Bergen Theater and Berta's, which once held a saloon called The Office. The Blue Goose, below, owned by the Mascolo family, was a mainstay in town for almost 50 years.

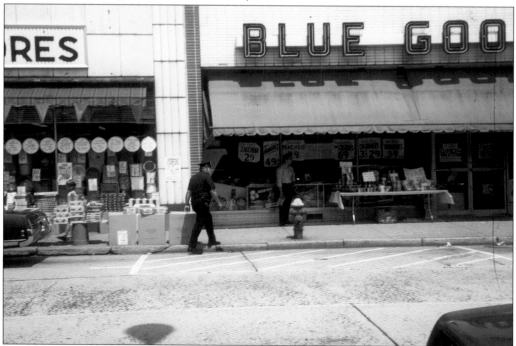

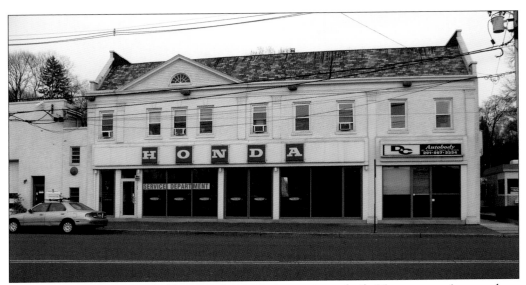

The Tribune Building has held various businesses since it was built 85 years ago. Among them are the post office; the *Northern Valley Tribune*, a local weekly newspaper; and a women's clothing store. D&C Chevrolet, now Honda of Tenafly, successfully run by Tenafly's own Dorf family for over 70 years, started off in the portion of the building farthest north (left) and eventually took over the entire structure as the business grew.

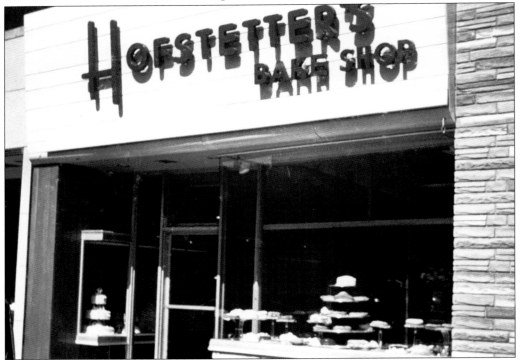

The Hofstetter family opened their popular Washington Street bakery in 1934. This is a 1950s view of the outside of the building. Hofstetter's Bake Shop closed in 1965, but new owners have kept the business of fresh-baked goods going at this location, now Miller's Bakery.

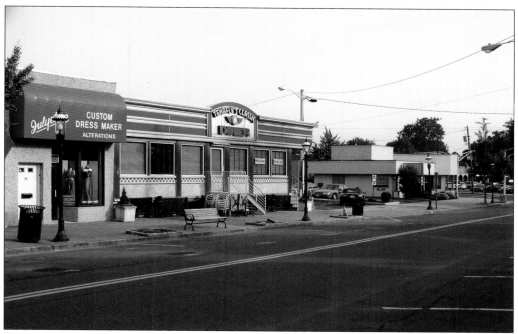

This is a view of the Dairy Queen and Diner in contemporary times. This is the third version of the diner in the same place. The beloved Dairy Queen is now Alma Bank. (Author's collection.)

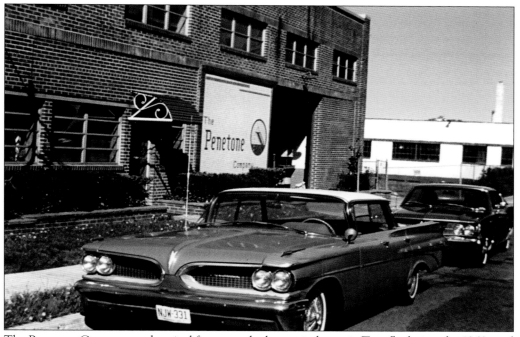

The Penetone Company, a chemical firm, was the largest industry in Tenafly during the 1960s and 1970s. Its complex stood on Hudson Avenue, now the site of the Tenafly Plaza Condominiums. This photograph dates to the late 1960s.

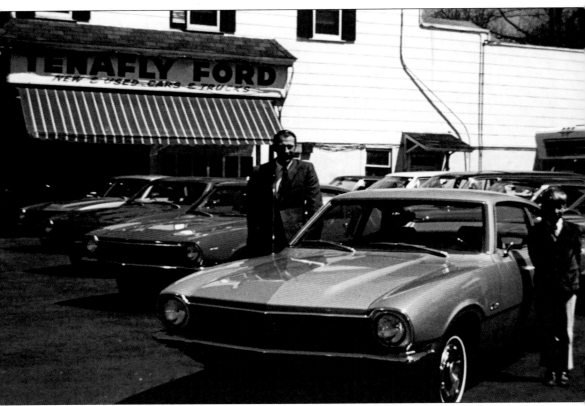

Tenafly Ford, later Kost Ford, on County Road had the first of the new 1970 Fords on display, as seen in this photograph. Proprietor Ronald Mulliken Jr. is shown with his son Ronald III. The location closed in the 1990s after serving generations of residents. It is now a location for sales of pre-owned BMW vehicles.

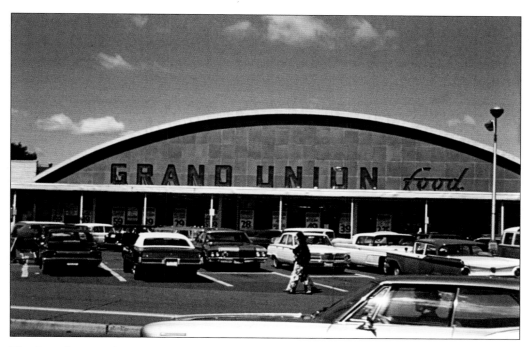

The Tenafly Grand Union, pictured above, later the Stop n Shop, was the centerpiece of the shopping center built in the early 1950s on West Railroad Avenue. The facade has only recently been renovated. Below is the grocery manager of many decades, Charlie Maschi, whose familiar whistle was known to many who shopped in the store. This has become a family affair, as Charlie's daughter Maria is now in administration at the same location.

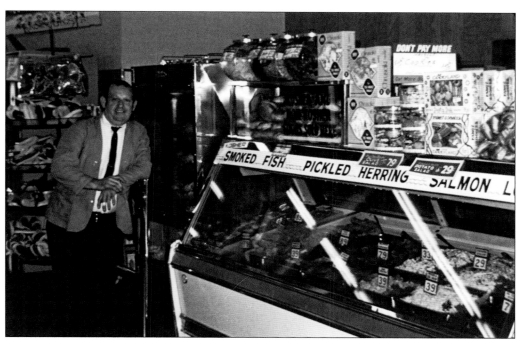

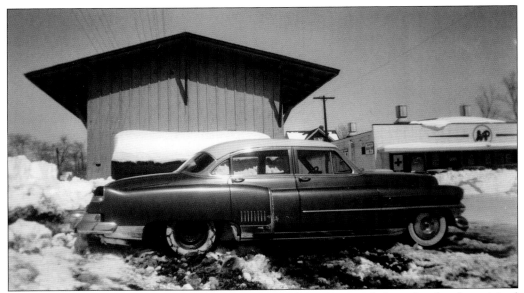

Behind the 1950s car (with snow chains on the tires) is what was believed to be the original railroad station that served Tenafly when the Northern Line reached the village in 1859. When the Atwood-designed station was being built in 1872, this structure was moved north up the line a hundred yards and served as a storage facility. To the right is the newly built A&P supermarket, now the site of Tenafly Gourmet Farm.

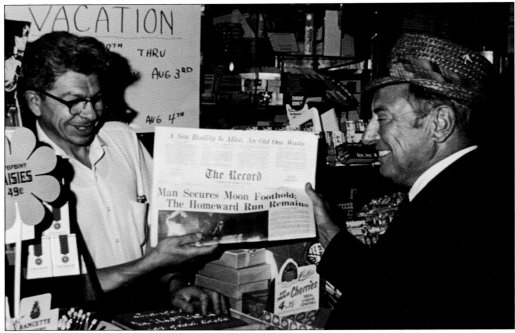

The Corner Store, later Tri State News, was a popular place to get newspapers, magazines, tobacco, magic tricks, and greeting cards and later even play video games. It had a telephone booth in the back! Here, a newspaper is being purchased in the Corner Store on a momentous occasion in 1969.

The Smith Building, redesigned with a new facade in the 1920s, was once Tenafly Hall, the first town hall in Tenafly. It was built in 1892 by private subscription. The town rented facilities for the police and fire departments and for meeting space. After the heat functioned poorly for long enough and visitors got tired of shoveling their own coal, the borough moved into a new Borough Hall on Washington Street in 1913. This building now holds numerous stores and offices. (Author's collection.)

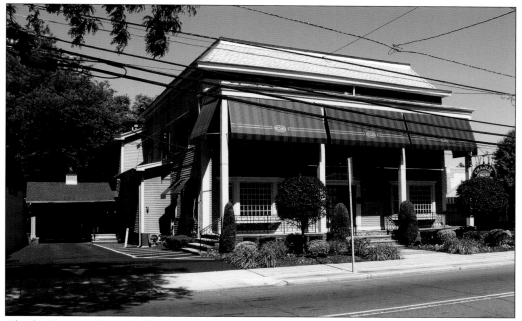

Charlie Brown's, formerly The Forge and Schackel's Tavern, was originally known as the Valley Hotel. Once a site for voting, it became famous for being the place where Elizabeth Cady Stanton attempted to vote in 1880, with Susan B. Anthony by her side. Her ballot was not accepted, but her attempt went down in history. The building met its demise in 2016. (Author's collection.)

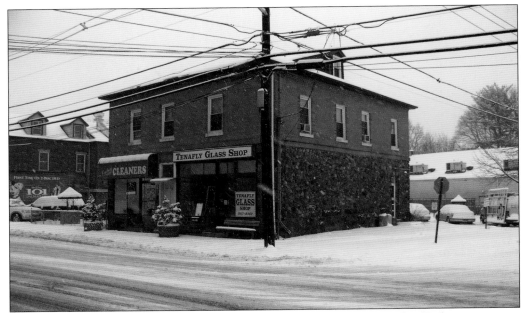

The cobblestones on this County Road building were hand laid by the family of Italian immigrant Fortuno Maragliano in the mid-1920s. Maragliano owned Maragliano's Deli, later taken over by his son Carl, in the building at left. Both buildings still stand today. (Author's collection.)

One of the cornerstones of downtown is this building on West Railroad Avenue at Washington Street, constructed in 1911. It has been called the Bower Building (constructed by the former owner of Bowers' Pharmacy) or the Oddo Building after a sweet shop. It contained the post office in the 1910s and 1920s. (Author's collection.)

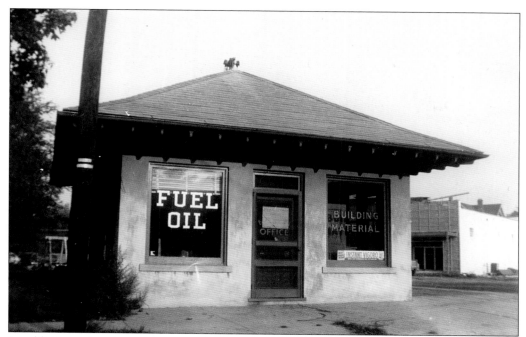

In addition to hardware at its prominent corner location, Demarest's had a fuel business run by Edwin Demarest (later by Warren Swift) out of this building. After the A&P—seen under construction in the background—was finished, this building was taken down and the fuel business moved to Hudson Avenue. This photograph was taken in 1954.

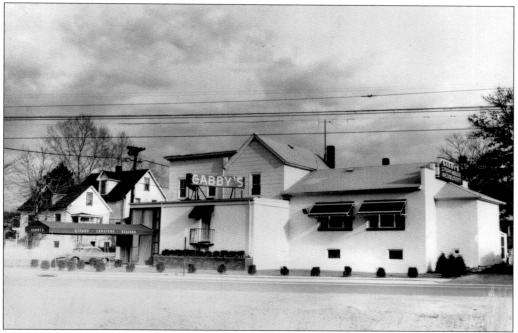

This 1950s photograph of Gabby's shows the popular eatery/tavern run by the Garbarino family. Later, this was the site of China Quarter, with its famed dragon mural, and after that, Lum Chin.

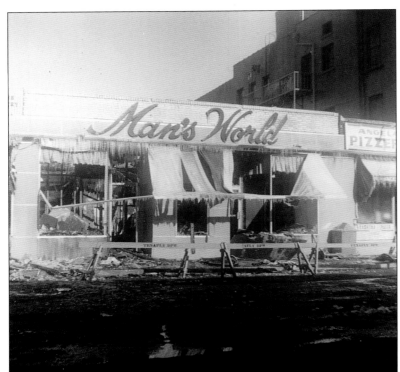

One of the biggest fires ever to hit downtown Tenafly raged out of control on December 24, 1967. An entire row of stores was lost on Washington Street, including Man's World. It was cold enough that the water used to put the fire out froze in the street. Those attending midnight services in nearby churches smelled the smoke. Firemen who were called to the scene barely made it home for Christmas dinner the next day.

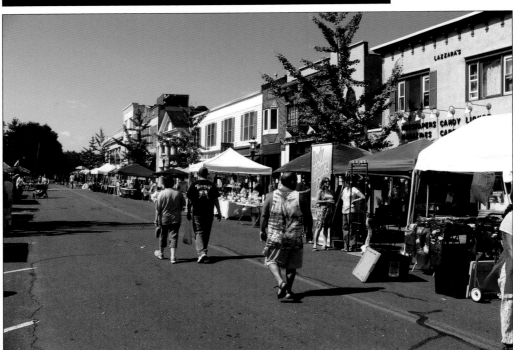

Over the decades, the old sidewalk sales of July have evolved into semi-annual street fairs. Patrons get a chance to see vendors and play games, while still visiting the familiar stores.

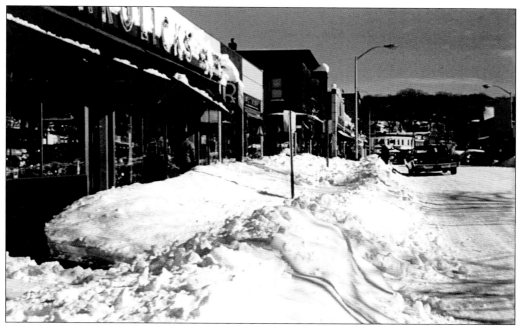

This winter storm in 1968–1969 dumped a lot of snow on downtown Tenafly, but Krolick's was still open for business. Just beyond that was Sayday's storefront. Krolick's sold everything from household items to toys and was the go-to place for two generations of students seeking school supplies.

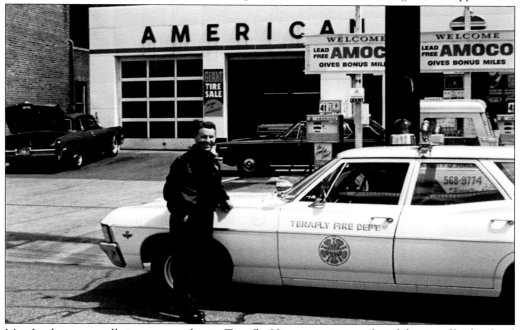

Moe Leahy was an all-time personality in Tenafly. His gas station employed dozens of high school students over the years and served thousands of residents. Leahy was fire chief in the 1960s. In his youth, he quarterbacked the Tenafly High School Tigers and eventually was inducted into the Tenafly Athletic Hall of Fame.

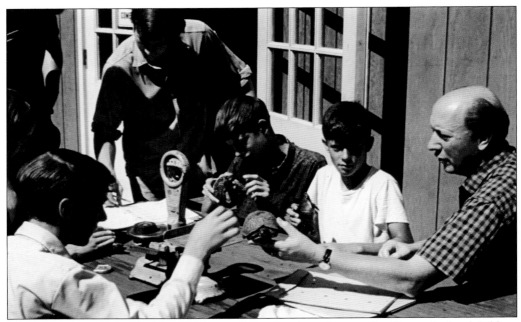

The learning center at the Tenafly Nature Center has been hosting families and schoolchildren interested in seeing its exhibits for over 50 years. Here, around 1970, founding member Don Zeiller shows kids a turtle up close. Zeiller was such a fan of turtles that he had a large fenced-in turtle pen in his backyard on Norman Place, where he could study their habits.

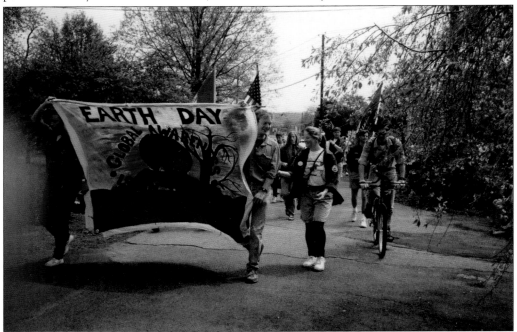

The first Earth Day celebration in Tenafly took place in 1994. Here comes the parade as it descends on Roosevelt Common. The school system and Environmental Commission, with support of local businesses, have been promoting environmental awareness for over 20 years.

Jon-Erik Hexum, known in town as "Jack," acted in the *Voyagers!* television series and the drama *Making of a Male Model.* He graduated with the Tenafly High class of 1976. He filled the town with school spirit and was often seen on the athletic field or in the production studio, as well as in the school's disc jockey booth. Hexum's life tragically ended in 1984 after an accident with a gun loaded with blanks while filming the series *Cover Up.* (Courtesy of the Jon Erik Hexum fan club.)

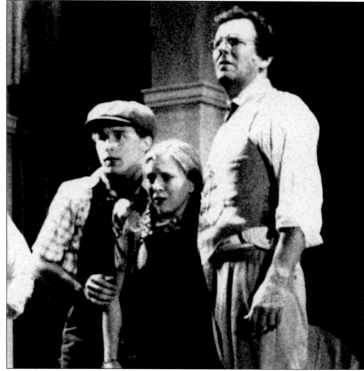

Having grown up in Tenafly and been a student at Maugham Elementary School, actor Jay Huguley found his way onto the stage and screen by way of the Peddie School in Hightstown and the University of London. Pictured in a 2015 theater performance of *To Kill a Mockingbird* at summer stock in Iowa, Huguley appeared in the Academy Award–winning film *12 Years a Slave.* His recent role on the *Walking Dead* has exposed him to a new generation of fans. (Courtesy of Jay Huguley.)

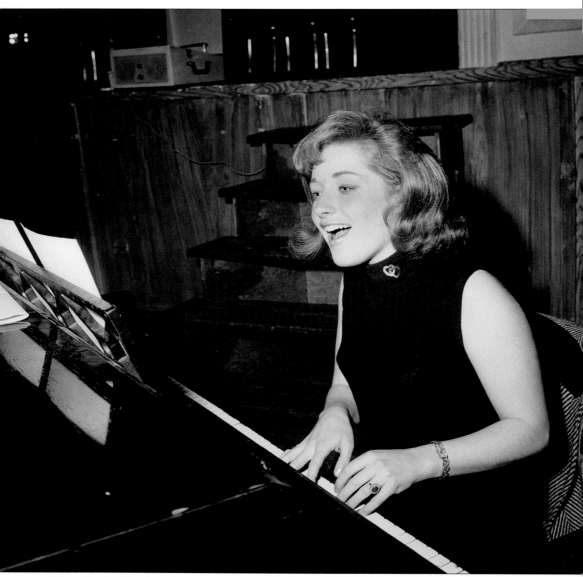

When Lesley Goldstein's piano and voice demo tape found its way onto Quincy Jones's desk, the career of 16-year-old Lesley Gore was born. A student at Tenafly Junior High School and later Dwight School, "the Sweetie Pie from Tenafly" had such hits as "It's My Party" and "You Don't Know Me," performing those songs at nearby Palisades Amusement Park. Lesley Gore passed away in 2015.

Five

PRESERVING OUR TOWN'S HISTORY

Elizabeth Cady Stanton had this home on Highwood Avenue and Park Street built around 1868. Stanton made her dramatic attempt to vote at the Valley Hotel (later Charlie Brown's) in 1880 but was denied. Early volumes of *History of Woman Suffrage* were written here by Stanton, Susan B. Anthony, and Matilda Joslyn Gage. The home was drastically remodeled around 1910 but remains a prominent house in Tenafly.

Dr. J.B. Lansing was a prominent physician in town following the retirement of Dr. J.J. Haring. Lansing served on the board of health as well. He had this house on Westervelt Avenue built in 1894. (Author's collection.)

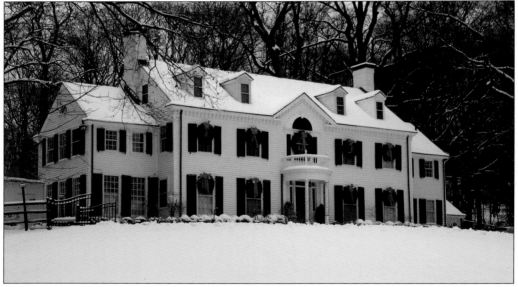

Karl "KBC" Smith was the developer of many fine homes in the mid- to late 1910s on Old Smith Road off Clinton Avenue, known as Old Smith Village. His own former home on East Clinton Avenue is one of Tenafly's most attractive, with a brook running in front. The house later was occupied by a major Tenafly Library benefactor, Charles McCandless, who called his home Oak Hill. Every winter, many who drive through town admire the home as it is decorated by wreaths that are lit at night. (Author's collection.)

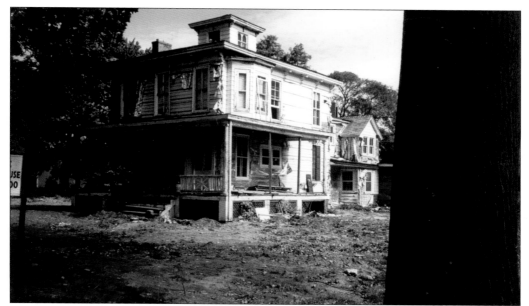

The Durie House, later called the Alex Roberts House after the early borough official who lived in it through the 1950s, had a portion that dated to the Revolutionary War era. A years-long battle to preserve the house was lost in 1994, but the historic preservation effort gained steam. Historic sites around town received landmark status, with the Tenafly Historic Preservation Commission working with the planning board and mayor and council.

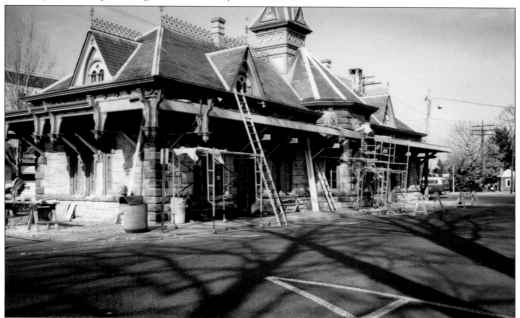

The historic Tenafly Railroad Station, designed by Daniel T. Atwood, is listed in the National Register of Historic Places. It underwent its most dramatic renovation during the mid-1990s, when, after years of donations and grants were received, the overhang was reinstalled and the slate roof repaired.

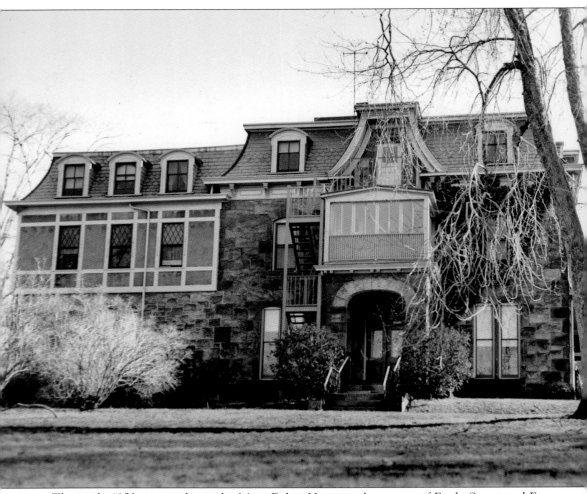

This early 1950s image shows the Mary Fisher Home at the corner of Engle Street and Forest Road, the second of three locations for this home. This stone home appears in the 1876 Walker Atlas as the Waddell House. The structure was taken down and redeveloped in the mid-1980s, but the stone entrance pillars remain.

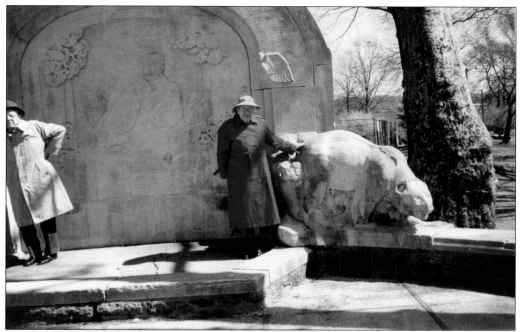

As borough historian from 1963—and unofficially for 10 years before that—until her retirement in 2003, Virginia Mosley tirelessly told Tenafly's historical story. She founded the Historic Preservation Commission in 1988, serving as its first chair, and promoted restoration projects, such as the monument seen above at Roosevelt Common. Below, a woman looks at the War Memorial in Huyler Park, erected in 1923 in honor of those from Tenafly who served during World War I.

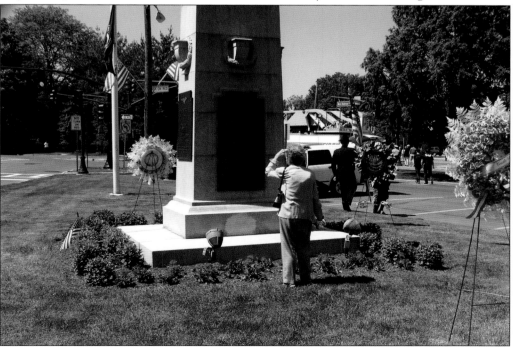

This early 1970s view of the Davis Johnson house is from before the family donated the property to the town for a park. The mansion was demolished, per the family's wishes, except for the foundation, which remains part of today's Davis-Johnson Park.

Many may not realize that the eastern drive through Davis-Johnson Park is actually a pass through the foundation of the original house. Alliene Davis-Johnson donated the land for the park to the town with the condition the house be taken down first so the park would remain passive.

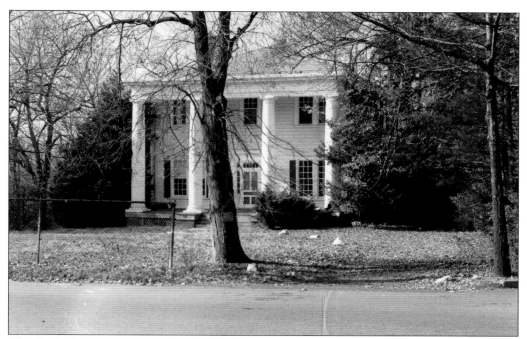

This Engle Street house shows up on the 1876 map of Tenafly as the William King home. After two generations of the Noyes banking family living in it, the house was demolished in 1995. The Borough of Tenafly purchased the two-acre lot and made it part of Davis-Johnson Park.

This mid-1970s shot shows the many tulip plantings done during the early days of Davis-Johnson Park, with the original garden building seen in the background. The borough has since replaced the garden house with a state-of-the-art facility that includes a meeting room and greenhouse.

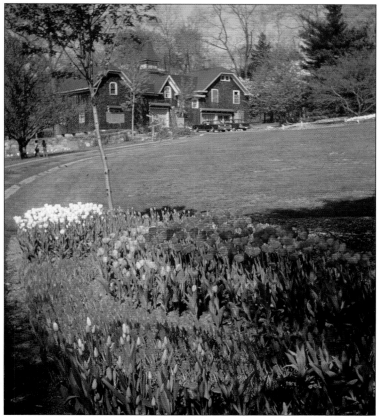

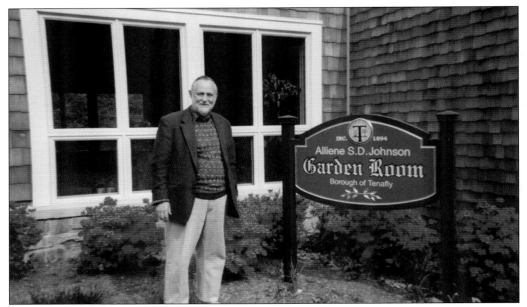

Included as part of Davis-Johnson Park was a garden building, which was where the gardener lived when the estate was occupied. Once it fell into disrepair, a new facility was built in 2003 and included new greenhouses for the Garden Club, storage areas, and a small banquet facility. Pictured in front, after the dedication, is the Historic Preservation Commission chairperson at that time, Dr. Donald Merino. (Courtesy of David Wall.)

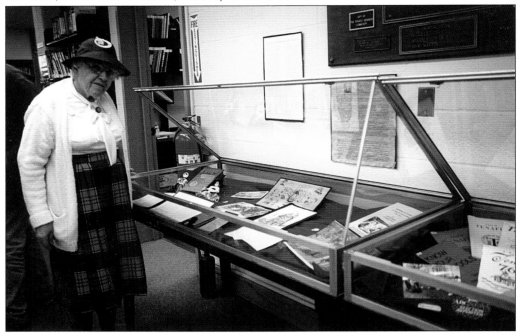

There have been many publications over the years that are about Tenafly or involve the town. Virginia Mosley stands in front of a library exhibit of publications by the Tenafly League of Women Voters.

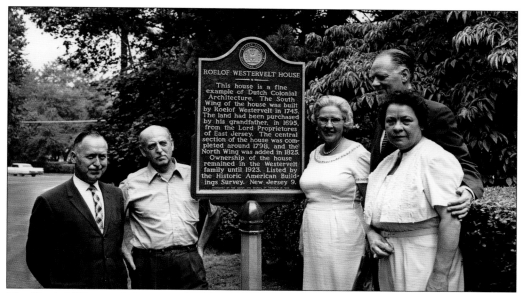

The Roelof Westervelt house at 81 Westervelt Avenue is a local landmark. Here, *New Yorker* cartoonist George Price, second from left, who lived in the house when it got its blue county historical marker in the 1960s, poses with town officials. Historic preservationist Kevin Tremble and family have kept the house authentic and an example of historical integrity.

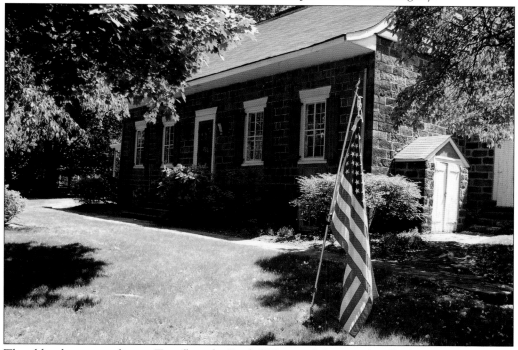

The oldest home standing in Tenafly is the Roelof Westervelt house, a locally designated landmark that is also listed in the State and National Registers of Historic Places. The oldest portion of the house (southern) dates to about 1745. Descendants of the original Dutch family lived here until 1923. (Author's collection.)

The DeMott family had a large presence in Tenafly from the 18th century into the 20th century. James B. DeMott died while serving in the Civil War in a New Jersey unit captained by fellow resident Colonel Demarest. On what was once a single large land parcel stood two of the houses belonging to that family. Above is the Knickerbocker Road house that belonged to former Tenafly mayor Richard DeMott (recently demolished). Below is the house belonging to Richard's father, John Hopper DeMott, where Richard grew up. It still proudly stands on Tenafly Road near Oak Avenue. (Author's collection.)

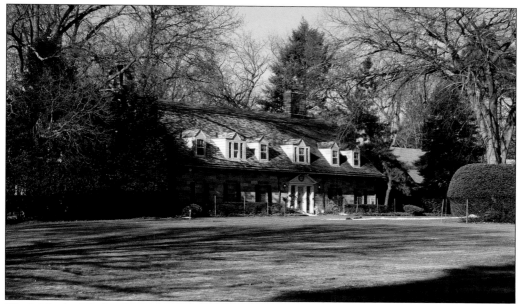

The Malcolm Mackay house on Knickerbocker Road dates to approximately 1919. It was designed by architect Frank Forster and built in the Dutch Colonial Revival style. Malcolm Mackay was a Wall Street financier and philanthropist in Tenafly and has one of the borough's four elementary schools named for him. Donald Lowe of the New York Port Authority later lived in the home, which is scheduled to be redeveloped during the next year.

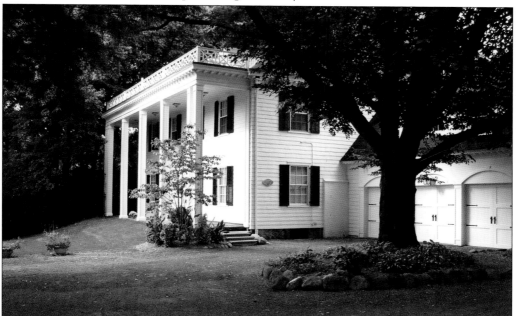

The Coddington House at 6 Marcotte Lane is on the 1982 Bergen County survey of historic Tenafly homes. It used to face Knickerbocker Road directly. Mabel Coddington, who grew up in the house, recalled the days of her youth in the 1920s, seeing caddies from Knickerbocker County Club resting in her backyard—or relieving themselves. "Back to work!" her father would yell.

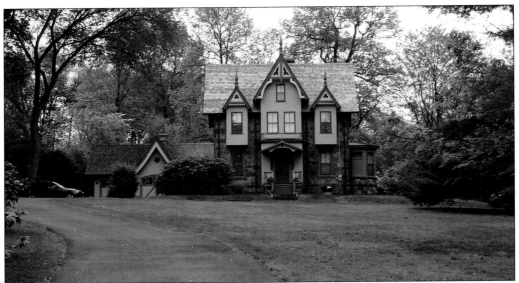

Tenafly's Atwood Historic District is named for architect Daniel T. Atwood, who designed several of the 1870s-era homes in the neighborhood, including the Benjamin Pond house, a Gothic structure on Serpentine Road. Built about 1871 and known in Atwood's book as "Design One," the home was once occupied by early Tenafly official Benjamin Pond. Below, Benjamin's son Henry, "the father of the Planning Board in Bergen County," who grew up in the house, receives a copy of the Tenafly 75th anniversary book in 1969. Henry had been active in town for 75 years at that point; he had purchased a share of Tenafly's first town hall in 1892.

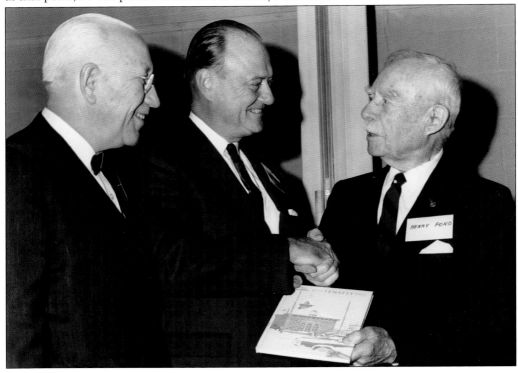

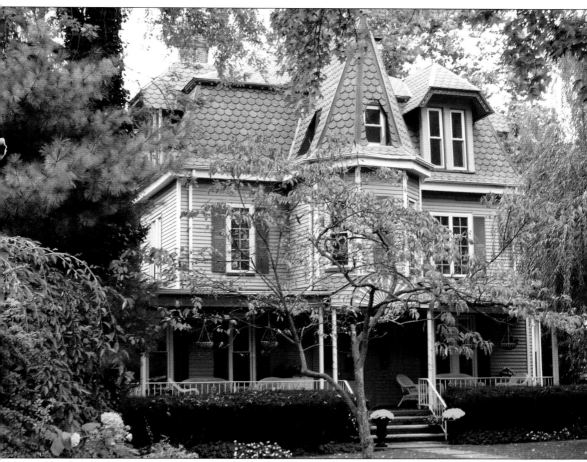

Henry Palmer, who was a borough founder and served three terms as mayor, lived here. This unique house is in the heart of the Atwood Historic District of homes, designated in 1997, many of which were designed by renowned local architect Daniel T. Atwood, who also designed the Tenafly Railroad Station. (Author's collection.)

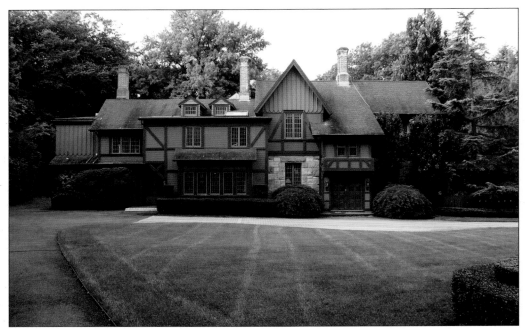

Artist and illustrator Harvey Dunn lived at this residence on Forest Road from 1918 until his death in the early 1950s. The home is on the Bergen County historic register. Dunn worked out of a detached studio, accessible via a path through his backyard. The home is now a private residence on Depeyster Road. Below, some of Dunn's artwork can be seen in his study/library in this interior shot taken about 1950. (Below, courtesy of South Dakota Art Museum.)

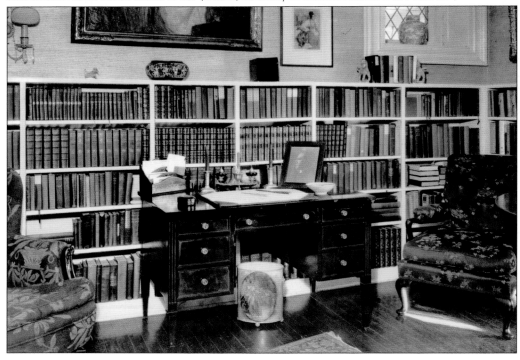

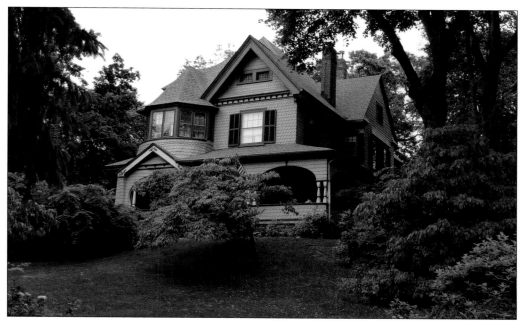

The Colver House, in the Magnolia Historic District, was the home of early Tenafly mayor and publishing scion Frederic Colver. Colver was one of the few gentlemen who launched the idea of Tenafly becoming an independent borough, breaking away from Palisades Township in 1894. It is now under diligent caretakers, the Barone family.

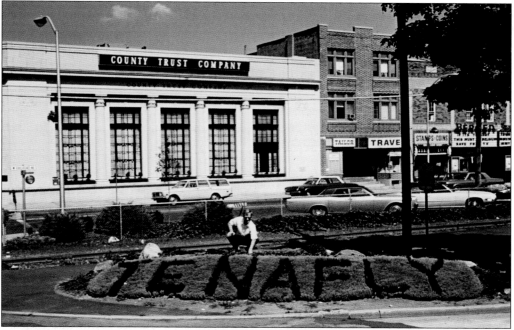

The County Trust Bank building was constructed in 1923. The name of the bank has changed a few times over the decades, but the distinguished edifice has been a part of the historic West Railroad Avenue streetscape, which runs as a backdrop to the landmark Railroad Station, ever since.

Discover Thousands of Local History Books
Featuring Millions of Vintage Images

Arcadia Publishing, the leading local history publisher in the United States, is committed to making history accessible and meaningful through publishing books that celebrate and preserve the heritage of America's people and places.

Find more books like this at
www.arcadiapublishing.com

Search for your hometown history, your old stomping grounds, and even your favorite sports team.